Indiancraft

by

Chief W. E. "Dode" McIntosh

and

Harvey Shell

Illustrated by Kay Shell

Library of Congress Cataloging in Publication Data

Chief W.E. "Dode" McIntosh, 1893–
Shell, Harvey, 1943–
　　Indiancraft.

Information here.

ISBN 0-87961-170-7
ISBN 0-87961-171-5 (pbk.)

Naturegraph Publishers, Inc.
3543 Indian Creek Road
Happy Camp, CA　96039
U.S.A.

Books for a better world

Table of Contents

Acknowledgements

The writing of a book such as this is never a one or even two-person job. It is, instead, the collective skills and knowledge of hundreds (perhaps thousands) of persons both in the past and present, beginning with the first craftsmen who made some of the items featured in this book and continuing down to the present authors.

To list all of these people would be impossible, even if their names were known. The authors, however, wish to extend special thanks to the following for their help: Dan McPike of the Gilcrease Institute, Tulsa, Oklahoma; Woodrow Haney, Indian flute maker, Tulsa, Oklahoma; E.L. Gilmore, Cherokee Tribal Historian, Tahlequah, Oklahoma; and Tom Blair, Indian artifact and craft collector, Tulsa, Oklahoma.

Also, very special thanks go to two people without whom the idea for this book would never have occurred . . . Lulu Vance McIntosh (1893–1986), and Roxanna Chamberlin.

Preface

Many books have already been written about Indian crafts and costumes. To that list must be added another title—that of this book. It should be noted here that this is not an attempt to replace any of those previous books, in particular those of the great W. Ben Hunt. It is, instead, our attempt to update these books into a somewhat more modern format. This is necessitated by the increasing difficulty in obtaining the natural materials used in Indian crafts. The great majority of people can no longer go out and trap their own otter and porcupine; and, with the rise of apartments and close-set suburban houses, tanning your own deer hide might well cause some neighbors to complain.

Another reason for writing this book is that Indian styles have changed considerably since many of the earlier books were written. Designs that once were the exclusive property of one tribe are now universal among many tribes. Dance bustles, which began as bird skins on the dancers, have evolved into the huge, impressive, and beautiful Oklahoma "Fancy Dance" bustles, preferred by most Indian dancers today.

Most Indian crafts are not easily done. Though some are simple, most require a great deal of time, patience, and a degree of skill. The rewards, however, are more than worth the effort, and most persons who try these crafts agree that the self-satisfaction and the product of their time is more than worth the effort spent in the production. It is our hope that you, too, will try these crafts and find the thrill of seeing your knowledge and skill of this ancient form of crafts grow.

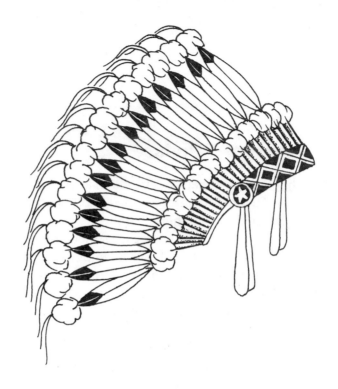

Warbonnet

Originally attributed to the Crow Indians, you would now have a hard time finding a tribe who doesn't wear these beautiful headpieces—not only because people expect it, but because the warbonnet, more than any other item, symbolizes the Indian spirit. For that reason, the warbonnet is in this book (and every other Indian craft book that's been written).

For this project, you will need 32 imitation eagle feathers (16 left and 16 right), 64 base plumes (bright fluffy feathers 4 to 6" long), 32 tip plumes 2 to 4" long, an old felt hat, some red felt, a leather thong, colored string, and waxed string. If you can acquire some horsehair, this will add a nice touch. And, lastly, you will need some white glue.

The first thing to do is to prepare the feathers. This is done by holding the feathers close over a lamp and straightening them by heating and bending. Soak the quills in hot water and cut a section out of the quill about 1/2" from the tip. This section should be about 1" long. Now bend the tip up and fit it inside the cut section of the quill so that the cut part forms a loop (Figure 1).

An alternate method to cutting the loop from the quill is to use a 1/4" wide strip of leather, folded over, and slipped onto the quill until only a 1/4" loop is left. The leather is then tied in place. You may also wish to use a drop of glue to help hold the leather in place while you add the plumes and wrap the felt around the quill (Figure 2). If you desire, more color may be added to the warbonnet by wrapping bright (possibly gold) embroidery thread around the felt at the base of the feather.

Now you are ready to apply the base plumes. Use two base plumes for each main feather. Glue the plumes or tie with thread to

Figure 1.

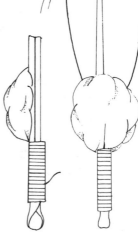

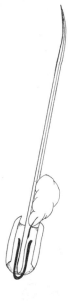

Figure 2.

the quill 2" above the loop. Now take a piece of red felt 1 1/2" x 1" and wrap it around the quill so that it overlaps the tip of the base plumes and extends down to the top of the loop. Hold the felt tight and wrap the colored string around it. To hold the felt in place, the string should be wrapped at top, bottom, and middle.

Next comes the top of the feather. If you have the horsehair, lay aside 8 or 10 strands, 12" long. Glue a small square of leather to the top of the feather and glue the horsehair to that piece of leather. Now glue the tip plume on top of the horsehair. You must do all 32 feathers in a similar manner.

Take the felt hat and cut away the brim and lower front part of the crown so that it fits you somewhat like a snug helmet. Make sure that the front line of the cut is even and mark a line one inch above this cut. This line should extend back to your ears.

Measure the distance around the crown and divide this by 32 (approximately 1/2"). Make 32 marks around the crown, using this distance. Begin at the front of the crown and measure so that your first mark falls halfway to either side of the center point. Now, take a small, sharp knife and make two slits—each one 1/4" long and 1/8" on each side of your mark (Figure 3).

You are now ready to put on the headband. If the band has beadwork or quillwork, the best way to attach the headband is to sew it on. If you cannot get either beadwork or quillwork, ribbons cut into an Indian design and sewn or glued on work well. Next come the drops which go on either side of the headband and fall in front of the ears. Fur is best, but ribbons work well, as do feathers. After that come the rosettes which are sewn in place over the drops. If you cannot get bead or quill rosettes, small 2" round mirrors glued to leather backs

Figure 3.

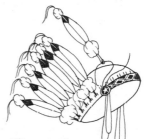

Figure 5.

Figure 4.

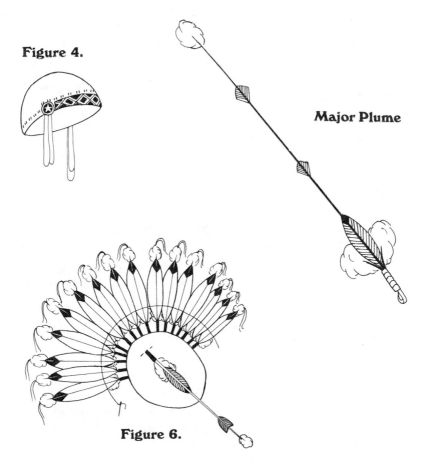

Major Plume

Figure 6.

9

work quite well and are authentic (Figure 4).

Take your prepared feathers and separate them, left and right; then arrange them according to size. You are now ready to assemble your warbonnet at last. Begin at the center point of the crown and lace your leather thong through the slits in the crown. As the end of the thong comes out of the first slit, insert the thong through the loop of the feather, beginning with the largest feather of the left or right group (whichever way you work), and work to the smallest feather which should end up at the back of the crown. When this is done, do the same with the other half of the feathers (Figure 5). When finished, take your waxed string on a heavy needle and run it through the back of the quill, behind the webbing, and about 4" above the loop. Be very careful not to let the webbing or the base plumes come into contact with the string as it will pull them through the hole. Do this to each feather, leaving about 2 inches between each feather and tie the two ends together when finished (Figure 6).

Now decide whether you wish to put a major plume on your warbonnet. Although many warbonnets do not have one, the addition of a major plume gives a bonnet the extra touch which raises it from good to very good.

The major plume should be the longest feather you have—1 1/2 to 2 times the length of your standard warbonnet feathers. Begin your major plume by stripping away most of the webbing from it, leaving a 3 or 4" section of webbing at the base and one or two smaller sections of webbing at intervals along the quill, plus a small section at the tip to which you will attach your tip plume. You now cut a section out of the quill tip, loop, and wrap it as you did with your other feathers and add a couple of plumes.

The major plume should be sewn onto the warbonnet in the center of the crown and about midway between the top and the front of the bonnet. It should then lay back on the head so that its tip comes out approximately in the center of the circle of warbonnet feathertips.

There is no standard design for a major plume. The webbing pattern should reflect your taste and mark your individuality. Very seldom will you find a feather long enough to make a major plume. To overcome this problem, use two feathers, cutting the end off of the larger one and inserting the quill of the smaller one into it. When stripped, this joint is very difficult to notice.

Arrange the feathers for best appearance and enjoy the results of your labor!

Warbonnet Box

Now that you've made the warbonnet, the next thing you will need is something in which to store it. If left unprotected, a warbonnet quickly becomes a mess—its once brilliant feathers becoming broken, dirty and half-eaten by insects. The solution to this happening is, of course, a storage box for the bonnet.

To make a storage box, a large cylinder is required. The cylinder may be metal, wood, or pasteboard, whichever you can come by most easily. This piece of material should be about 7 or 8" wide and 24" tall (Figure 7). A word of warning here. If you are making the storage box for a tailed warbonnet, it must be wider—12 to 15," for example—as a tailed bonnet would not roll up tight enough to fit into the smaller case.

If your tube does not have a top or bottom, you must make one at this point. There are various ways to make a bottom for a warbonnet case. The most commonly used method is to cut a disk out of 3/4" wood just large enough to fit inside the cylinder, then nail it in place. If the cylinder is of metal, it will probably be necessary to punch holes through the metal first. Once the bottom is in place, cut a slightly larger circle for the top of the box. The disk for the top should be just large enough to rest on top of the cylinder and not fall into it. The next step is to find a thin strip of metal, 2" wide and long enough to go around the disk. Thin wood may also be used; however, it will be necessary to soak it in boiling water until it is soft enough to bend around the disk without breaking. Once you've placed your strip around the disk, nail it in place and attach your securing straps.

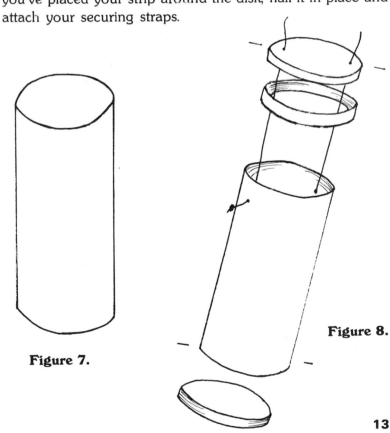

Figure 7.

Figure 8.

13

The straps are secured by drilling two holes—one in each side of the cylinder—about two inches below the lower edge of the cover lip and two more holes in the cover, approximately one inch from the edge (Figure 8).

Now you are ready to paint your bonnet case. If the case is made of wood, you may wish to leave the outside natural colored; however, the inside should be inspected and painted to be sure that it is smooth, as any loose splinters could catch and damage the warbonnet. The top and bottom of the case should also be painted. The case should be painted a dark cream or buckskin color.

You may use whatever designs you desire to decorate the case; however, you may wish to choose Plains designs rather than Woodland, as the warbonnet was originally from the Plains. Once the designs have been painted on, the only thing left is to install the tie-down thongs. This is done with two strips of leather about 18" long. Tie a knot in one end of each thong and feed them into the holes in the side of the cylinder, one thong in each side from outside to inside. Then run each thong up through the hole in the lid and tie them together to hold the lid in place.

You are now ready to store your warbonnet, but don't forget to put an unwrapped stick of spearmint gum, moth balls, or a package of Bull Durham tobacco in the bottom of the case to keep insects out.

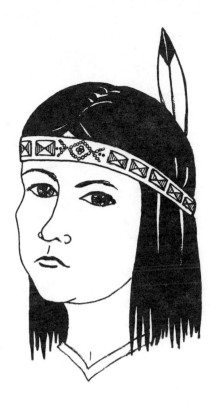

Headbands

Headbands were used by almost every tribe in North America. They can be either very simple or quite complex, depending on how fancy you want to make them. We will start out with one of the simpler designs first.

The first way to make a headband is to take a strip of leather about 1" wide and long enough to go around your head with a 2" overlap. Now cut two slits 1/2" apart and 1" long. The slits should begin about 1" from each end. Bring the two ends together to form your loop. Then, when the slits are parallel to each other, push them open and insert your feather. The feather will act as a stop so that the band cannot pull apart. You may wish to bead the headband, add quillwork or a rosette, depending on your taste (Figure 9).

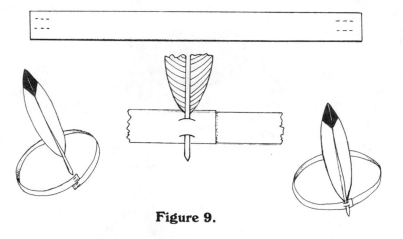

Figure 9.

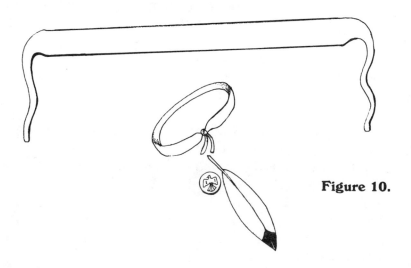

Figure 10.

Another and even simpler way to make a headband is to cut a strip of soft leather 1/4" to 1/2" wide and tie the two ends together around your head and attach the feather at the knot. This type of headband is best used when you want the feather to hang down on one side of the head with the knot often concealed by a rosette (Figure 10).

A third means of making a headband is to cut a strip of leather just large enough to go around your head and sew the two ends together. This method is quite often used on wider headbands, such as those an inch or more in width.

Roach Headdress

Just as the warbonnet spread from tribe to tribe and came to symbolize the Indian, so the roach has almost come to symbolize the Indian dancer. Nowadays, fully 90 percent of the younger male dancers sport this most fashionable of Indian dance apparel.

Porcupine hair makes the best roaches. This, however, is very hard for most people to get. Horsehair makes a very good substitute and is much easier to obtain. If you cannot find either of these materials, you can use hemp or sisal, raveled and straightened by stretching.

Begin by cutting your base. This should be of three or four layers of felt, depending on the weight of the material. With very light felt, you may want to use five layers. Cut the felt into teardrop shapes 2" wide at one end, by ten" long, and sew the pieces firmly together (Figure 11).

Figure 11.

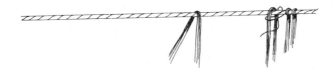

Figure 12.

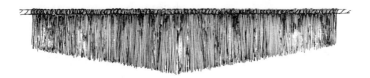

Figure 13.

Now you are ready to do the fringe. Begin by tying a heavy cord 2 to 3 feet long and 1/8" thick to two solid supports. Cut your fringe into 18" lengths and divide it into bunches of about 12 hairs each. Take a bundle of hair, fold it in half and lay the middle across the cord near one end. Take a waxed string and tie one end around the cord on the outer side of the fringe bundle. Hold the bundle by the end and pull down with one hand, while with the other hand bring the string around the bundle and pass it through the space between the bundle and the tied end of the string. Pull this tight. Now take the string to the other side of the bundle, over the cord, and pass it between the underside of the cord and the string. Pull this tight. Place another bundle on the cord and repeat the instructions, using the first bundle as the tied end of the string (Figure 12). Keep repeating the steps until you have 22" of fringe tied to the cord. Then tie the string securely and cut off the loose end. Cut the fringe so that it is 6" long at each end and 9" long in the middle. When stretched straight, the fringe should now form a shallow arc from one end to the other (Figure 13). Untie the cord ends and double the fringe. Mark the center point so that you have 11" on each side. Also mark the center point of the felt base. You should begin sewing at these points. Place the fringe on the top edge of the base and sew it to the base firmly enough so that it will stand up by itself. Sew one side and then the other. Where the ends meet in back, be very careful to do a good job as this is where unraveling is most likely to occur (Figure 14). This completes the main part of the roach; however, it not yet finished.

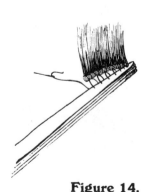

Figure 14.

The next step is to attach

the tie strings. There are two ways to do this. The first is to attach leather thongs to the roach with which to tie it on. The first set of tie strings should be two inches from the front of the roach. The second set, one inch from the end. These may be run through holes in the felt base or sewn in place. The back tie strings should be tied in place between the lower lip and the chin. This may seem strange, but it is the proper way to do it. The front tie strings should go in place under the chin, though not too tightly or you might choke. This is the method most dancers prefer (Figure 15).

The second method is to attach the roach to a headband by means of leather thongs or straps. This allows the roach to quickly be put on or taken off, and, with beading on the headband, can be very attractive (Figure 16).

The next thing you will need is a roach spreader. This is a device which slips inside the roach on the top front of the base and pushes the fringe outward to give it the desired spread, as many dancers prefer the fringe to be spread nearly horizontal rather than straight up and down. This can be made of bone, wood, leather or almost any stiff material. It should be cut in the same shape as the front part of the base, only slightly larger. You may need the spreader to be as much as 1/4" larger all the way around, depending on how flat you want the roach to be. It need not be over 4" long. Make one and fit it in place. If the roach lies down too much, cut the spreader down until you get the desired angle on your fringe. Once the proper

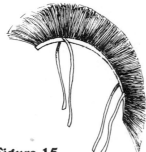

Figure 15.

Figure 16.

Figure 17.

size is found, make two sets of matching holes in both the spreader and the base. The first hole in the base should be in the center and 1" back from the front of the fringe. Lace a short leather thong through these holes with which to tie the spreader in place (Figure 17).

Roach feathers are the next item to prepare. This can be done using several methods and either one or two feathers may be utilized. We shall first discuss the single feather mounting.

First, you should prepare the feather. This is done by gluing four hackles to the tip of the feather, two hackles on each side angled so that they stand out from each other. (See chapter on feather terminology.) Over these, glue a small fluff to each side so that they cover the ends of the hackles. At the base of the feather where the webbing starts, similarly glue either three or four hackles on each side and wrap 1" of the base with colored thread or string (Figure 18). Next comes the feather holder, which is a cylinder about 2" long with a hole in the center large enough for the quill of the feather to fit into loosely. This can be made of wood such as an old thread spool, bone (a chicken's leg bone that has been well boiled works quite well), or metal (a spent shell casing looks very good). Drill a hole about 1" from the top through both sides of the hollow cylinder. The hole should be large enough so that you can fit a large needle through both holes.

The cylinder should now be attached to the roach spreader. This can be done by gluing or by drilling holes in the cylinder and the spreader and tying them together. The feather may now be inserted into the top of the cylinder and a needle and heavy thread run through the two holes in the side,

passing through the quill of the feather. The ends of the thread should be tied together and the feather should fit loose enough to wobble when shaken (Figure 18).

The double feather mounting is made much the same way, except that two feathers are prepared and a 12" piece of coat hanger wire is used. Bend this into a square Y shape with 2" on each angle. Cut off the base of both feathers just below the string wrapping and glue one to each of the upward pointing prongs of the wire. The bottom loop of the Y is then inserted into the tube on the roach spreader and a string is threaded through the hole in the tube and through the eye of the loop and tied in place (Figure 19).

Figure 18.

Figure 19.

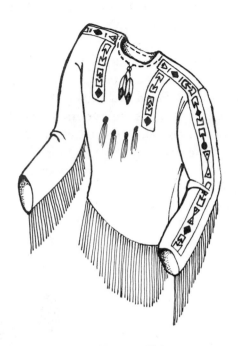

Indian Shirt

Certainly among the most striking articles of Indian apparel has to be the beautiful shirts made by many of the tribes. Actually, the Indian shirts can be subdivided into many different types, including, among others, the Woodland's shirts, Plain's shirts, war shirts, and ghost shirts as well as various tribal differences in cut and style of decoration among these types.

Making such a shirt involves a lot of work and not a small amount of money. So, before you start one, be sure you want it enough to finish the project.

The materials are the first consideration. White, brain-tanned buckskin is, of course, the most preferable. Unfortunately, this is also the most expensive and the hardest to find. If you cannot get this, a good quality, flexible, white- or buckskin-colored leather from a commercial tannery is the next best.

Suede also works very well. If you cannot get any of these, you can use leather- or suede-look cloth which can be found in larger department stores and cloth shops.

Once you have the material, you must make a pattern. This will allow you to cut out the shirt, using the least amount of material. To make the pattern, take one of your own shirts and lay it onto a sheet of newspaper or brown wrapping paper. Then trace around the shirt, leaving a margin of about one inch (Figure 20). Before you cut out the pattern and separate the arms from the body, remember that the arms must be twice the width of the pattern to enable you to fold the material over to form the sleeve. You will need the two sleeve patterns and a pattern for the front and back of the shirt.

Lay the patterns on the material and arrange them for the least amount of wastage. Then cut out the pieces and save the other parts to use for fringe (Figure 21).

At this point, you are ready to begin sewing. Should you be lucky enough to possess a commercial sewing machine, the job will be much easier or, if you are using the leather-look cloth, most regular sewing machines will sew it. If not, you have to hand sew the material, either by using a very heavy needle, a leather sewing awl available at leather and craft stores, or by punching holes with a sharp instrument such as an ice pick or awl and then running your needle through the holes (Figure 22). A fourth method is to punch sets of four holes, 1/2" apart, with 1" between the sets and lace leather thongs so that an "x" is formed in each set. If done in this manner, the material must be overlapped on the shoulders and sides.

When ready to sew the sleeves, first take a piece of the excess material with which to make the fringe and place it in the seam. Make the fringe as long as possible—6 or 8, even 10 inches are good lengths. You may have to make the fringe pieces by butting several pieces of leather together in the seam. This will not be noticed, once the fringe is actually cut.

Lay the pieces together with the side that will be the inside

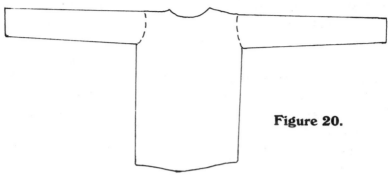

Figure 20.

Figure 22.

Figure 21.

Figure 23.

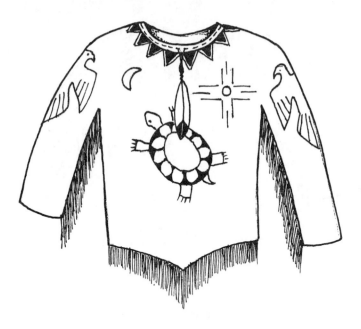

Shirt with Painted Design

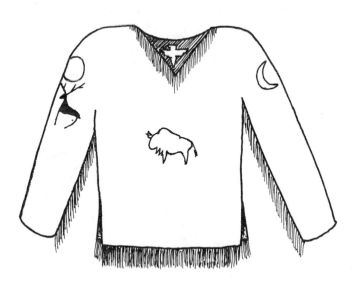

Old Style Shirt

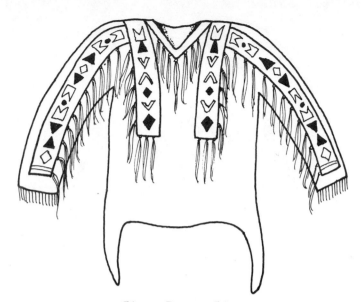

Ghost Dance Shirt

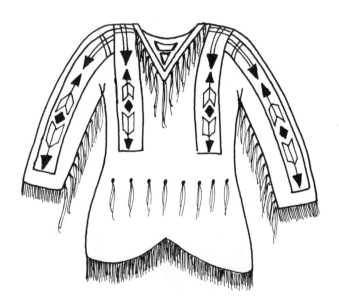

Later Style

of the finished shirt on the outside and sew the seams. On the sleeves, the fringe leather should be completely hidden, except for the edge sandwiched between the edges of the sleeve material (Figure 23).

Sew all of the seams and then turn the shirt right side out. You may now cut the fringe. This is best done with scissors, and very carefully. The thinner it is cut, the better it looks. Do the fringe on the sleeves and the tail of the shirt.

Once this is done, the shirt itself is finished except for the decoration which is what really makes a shirt stand out and marks the difference between an average shirt and a work of art.

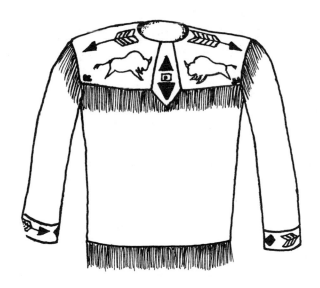

Shirt with Beaded Yoke

Beadwork is the most favored form of decoration. Quillwork is perhaps the most sought after. You may also do imitation quill or beadwork, or paint on your design—all of which are covered elsewhere in this book.

Other forms of ornamentation are placing tuffs of hair—either human or horse—on it, such as one would see on a scalp shirt. Also, the shirt can be decorated with imitation ermine tails made by carefully sewing a tube of white fur and dyeing the tip black.

The decoration of such a shirt is strictly a personal affair. You may want to use some of the traditional designs found elsewhere in this book and arrange them to suit your taste, or you can create your own designs which will have meaning only to you.

Five-Piece Shirt with Yoke

Another type of shirt can be made if your leather pieces are not large enough to make the front and back out of two pieces. This consists of making a yoke for the neck and shoulders. This will allow you to attach the front and back pieces to the yoke, rather than to each other, thus saving four or more inches on the main body of the material. Another advantage to this method is that it allows an extra row of fringe across the front and back.

Ribbon Shirt

Nearly every male Indian dancer owns a least one ribbon shirt and some have as many as a dozen. They are, in fact, the most commonly seen article of apparel at any Pow Wow, and the number of designs is limited only by the number of people wearing the shirts.

Making a ribbon shirt is not difficult if you can sew. If you can't sew—well, it's time you learned. Basically, the shirt is a loose-fitting, full-sleeved, slip-on shirt decorated with ribbons at the neck opening and on the sleeves. In earlier days, these shirts were made of cotton, usually with a small flower print. Modern Indians, however, make them from whatever cloth they wish and many are in shiny, solid colors.

Figure 24a.

64"

24"

To make the shirt, you will need 3 yards of cloth and about 13 feet of 1" wide ribbon. The color of the ribbon should be chosen to complement or to contrast with the shirt material, whichever you choose.

First, cut out the shirt pieces, using the drawings here as a general guide (Figure 24 and 24a). Then sew the yoke in place, leaving no more than half of the ribbon edge showing along the line between the yoke and shirt body. This is done on both front and back (Figure 25). Next, cut out the neck hole and front slit. Fold back material and face with ribbon. This may be sewn in place or you may use iron-on tape. Add snap or hook and eye at the top of the neck slit (Figure 26).

Pleat or ruffle the ends of the sleeves and sew on cuffs and cuff ribbons (Figure 27). Fold and sew the sleeves; then sew them to shirt body. Be sure excess ribbon is loose and will hang down on the outside of the shirt body. Now sew the sides of the shirt, leaving a 6" space unsewn at the bottom of the shirt on each side. Then hem all raw edges—shirt tail, side slits, sleeve ends, and cuff edges (Figure 28). Sew buttons or snaps on cuffs. These should be adjusted so that cuffs fit snugly.

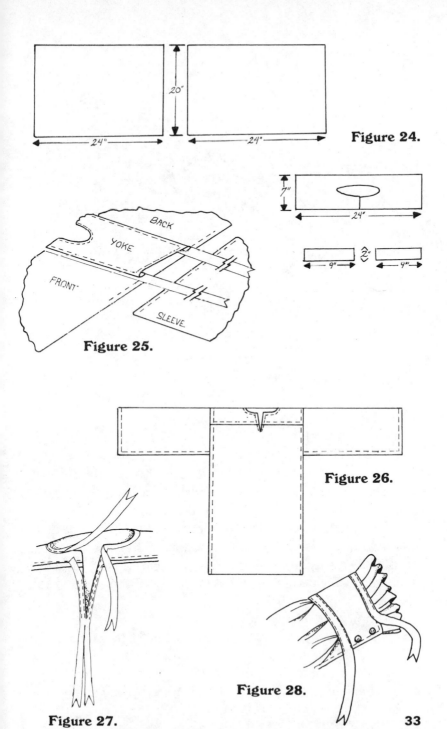

Figure 24.

Figure 25.

Figure 26.

Figure 27.

Figure 28.

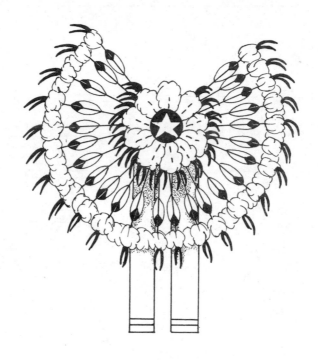

Dance Bustles

You will probably find making a dance bustle to be one of the harder projects in this book; but, with patience and attention to detail, you can have a bustle as attractive and well-made as any you will see on a professional dancer.

The problem with dance bustles is that they must be able to break down for easy transportation. Otherwise, you are stuck with transporting a three-foot circle of very delicate feathers in which you have invested not only your money but also a great deal of time.

The first thing you must do is to gather your materials. Once you have done this, the next step is to prepare 24 feathers. Cut a small section from the quill and form a loop in the same manner as was done with the warbonnet. Now, trim all feathers to the same length and strip away all of the

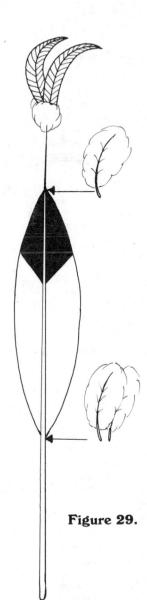

Figure 29.

webbing except for a 6" strip, beginning 2" from the tip. Now put two tip hackles on each feather. (You may use more if you wish.) Next, put on the fluffs just above the webbing. These should be glued and tied in place, as should the fluffs below the webbing (Figure 29). Once all the fluffs are put into place, lay aside the feathers and prepare the bustle board.

The bustle boards may be made of stiff, heavy leather, plywood, or masonite 1/8" to 1/4" thick—or even heavy pasteboard, though this last material is not recommended. You will need two round disks 6" in diameter of whichever material you choose. In the first disk, punch or drill two holes 2" apart—1" on each side of the center point (Figure 30). This disk may now be put aside for the moment. On the second disk, mark a circle 5" in diameter. Give the second disk a 1" border. Along this border, drill or punch 48 holes, 1/4" apart. Then make four holes, forming a square, with each hole 1" from the center point. Important: Two of the holes must line up with the space between holes 24 and 25 on the circle (Figure 31). You are now ready to place your main feathers on the board.

35

Figure 30.

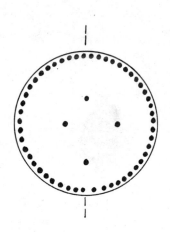

Figure 31.

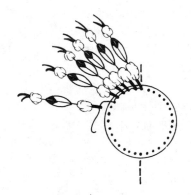

Figure 32.

Figure 33.

Divide the feathers into right and left groups. Thread a waxed string through hole No. 1 in the circle; run the string through the eye of your first feather, then thread into hole No. 2 and bring it out through hole No. 3. Place another feather on the string and run it into hole No. 4. Repeat this process until all 24 feathers have been attached (Figure 32). Tie the two string ends together. Next, you must take a very heavy needle and waxed string, passing it through each of the quills 3" up from the eye. After this is done, space the feathers evenly apart and tie the two string ends together. Run a cord or leather thong 4 feet long through the two horizontal center holes. This will allow you to tie the bustle around your waist.

You are now ready to prepare the inner bustle. Take the first disk and glue a circle of fluffs along the outer rim. Two inches inside the outer rim, glue a second circle of fluffs. Now take a 12" length of cord, leather, or thong and run it through the two center holes. Then glue a 1" diameter circle of fluffs around the center point. This will leave a 1" circle of bare material which is reserved for the rosette. The rosette should be glued in place, though it may be tied on by making holes in the disk (Figure 33).

To assemble the bustle, run the two string ends from the inner disk through the two vertical holes in the main disk; pull them tight and tie together. The bustle may now be tied around your waist (Figure 34). To disassemble the bustle, untie the cords and take the bustle apart. Then carefully fold the feathers of the main disk up until the circle of feathers is about the same diameter as the disk. The bustle may now be packed away in a container or cardboard tube.

This, by no means, is the last word on the bustle. You have a wide choice of colors to select from for the main feathers, fluffs, and hackles. The colors may complement each other or contrast. You can make the bustles larger or smaller, add feathers and fluffs, or take them away. In short, the bustle should be tailored to your taste. You are the one who will be wearing it, so be sure it pleases you. Use these instructions as

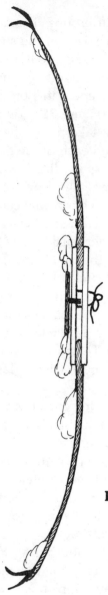

an outline to exhibit your taste.

You may also want to add bustle trailers. These are two strips of cloth, quite often of black velvet, about 4" wide and long enough to reach from the bustle board to your ankles. They should be edged with a contrasting design on the trailing edges and attached to the back of the main bustle board.

A smaller bustle is also worn by most dancers between the back of the neck and the shoulder blades. This can be made by making a smaller copy of your first bustle. How much smaller it should be is up to you. Most dancers prefer the smaller bustle to be about 6" less in diameter than the larger bustle, though some like for both bustles to be the same size.

Figure 34.

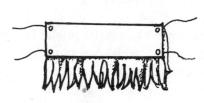

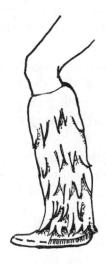

Figure 35.

Anklets

These are a necessity for the dancer of today and, like many other things, they have changed somewhat with the times. Formerly, the anklet was tied just above the ankle, hence, its name. Now, however, the anklets more deservedly should be called leggings as, now, many dancers prefer a longer version which ties above the calf. This term is not used though, as the Indians already have leggings of a different type—so the term anklets apparently will stay.

Instructions for both types of anklets are given here so that you may make your choice. Angora wool is the best material to make your anklets from; and, for the modern type, it is virtually the only material to use.

The older type of anklet should be made of wool; however, if you cannot obtain it, you can make an acceptable substitute by using yarn. To make it is quite simple and consists of a piece of wool hide about two inches wide and long enough to go around your leg just above the ankle (Figure 35).

Leather thongs at the ends allow the anklet to be tied in place (Figure 36). The modern type of anklet is made the same way, except that it is cut much wider so that it will reach from the top of the calf to the ankle in such a manner that the long wool will drop down to cover the top of your moccasins. Of course, you will need to add extra thongs to keep the anklet secure while you are dancing (Figure 37).

If you cannot get angora wool, you can make an anklet by cutting yarn into ten-inch lengths and attaching them to a leather thong with a simple loop knot. Two or three of these will give you the fullness you need for the proper appearance (Figure 38).

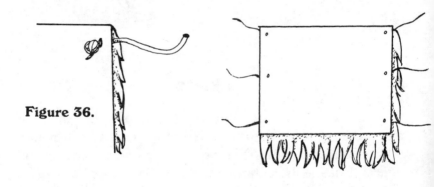

Figure 36.

Figure 37.

Figure 38.

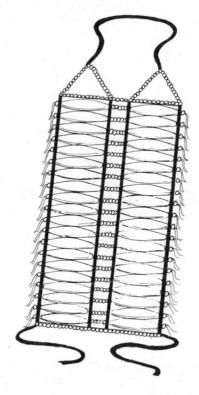

Hairpipe Breastplate

When looking at some of the old photographs of Indians, you will notice that one of the most striking items of apparel on many of them are the beautiful bone breastplates. These relics of the Plains tribes are extremely rare today; however, you can make your own breastplate with patience, a little skill, and possibly an outlay of some cash.

The most difficult part of making a breastplate could well be in finding hairpipes. You could make your own of course, but that would require a lathe and some very thick bone. You can also buy them from one of the Indian craft supply houses, but bone hairpipes are not cheap. An alternative is to buy plastic hairpipes which look good as long as you don't get too close. Another alternative is to make your own imitation hairpipes (Figure 39).

Figure 39.

Figure 40.

To make these, you need to get some thin (1/8") plastic soda straws and cut them to the length needed. Next, take a piece of newspaper of the same width as the straw and about 6" long. This paper should taper inward for the last 4" of its length so that the end of the paper is only about 1/2" wide. Dip the paper in flour paste and wrap it tightly around the straw (Figure 40). When the paste has dried thoroughly, sand the piece smooth and paint it white. You will need about 64 of these beads.

To make the breastplate, you will also need four strips of leather approximately 1/8" x 1/2" x 16," some large wood or glass beads, and about twenty feet of leather thong or heavily waxed thread.

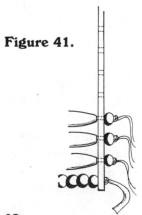

Figure 41.

Punch holes 1/2" apart in the four leather strips, being careful that the holes line up on all four strips. Once these holes are made, it's a simple matter to string the beads and hairpipes together, starting from the second hole down on the leather strips and stopping at the next to the last hole (Figure 41). When all of the hairpipes are strung, you need only put on the top and bottom straps and attach the neck and back ties to be finished.

Women's Dresses

Of all the items made by the Indians, perhaps none are more beautiful than the women's dresses. The making of a dress is not easy. It requires a great amount of time, money, patience and work. Do not start on this project half-heartedly.

The Skirt and Cape

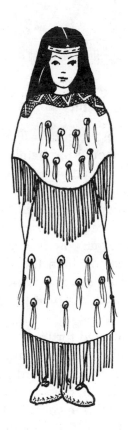

This dress has the advantage that it can be made from three or four smaller pieces of leather. These pieces should be large enough to make the front and back of the skirt, while the largest piece, or two smaller pieces sewn together, should be used for the cape. White is the preferred color, but a good buckskin also looks very attractive. If you cannot get leather, you may wish to use one of the imitation leather materials on the market. These look good, but are no substitute for a real garment leather.

Begin with the two skirt pieces. These should be folded over at the waistline and sewn, leaving a 1/2" gap between the seam and the top of the material through which the waist cord will pass. When held in place, the skirt should hang down far enough to cut the hem. After the waist seam is sewn, you should place the two halves of the skirt on the person for whom they are being made so that the hips and waist may be measured and marked with a pin or pencil (Figure 42). The next step is to place the two pieces back to

Figure 42.

Figure 43.

back and sew the seams. Then trim the excess material off the seams and cut the hemline (Figure 43). Should the hemline prove too short, it may be lengthened by first cutting a row of fringe around the hem. Then, place a longer strip of leather behind and just above the fringe. This may be attached by sewing or by gluing with leather or fabric cement. Once in place, this second piece should be fringed so that you have two rows of fringe at the hem (Figure 44). The skirt may now be turned right side out and the waistcord inserted.

Figure 44.

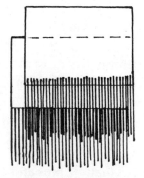

The material used for the cape needs to be a large piece of leather roughly square or round, according to your taste. Cut a hole in the center large enough for your head to fit through (Figure 45). Should you find your leather is not large enough for the cape, you may make it from two pieces, with the seam going across the shoulders.

Once the cape has been trimmed to your liking, you must

Figure 45.

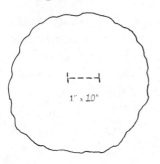

1" x 10"

cut the fringe. By today's standards, the longer the fringe, the more desirable it is. Bear in mind however, not to cut the fringe too deep, for modesty's sake.

Once the cape is cut and fringed, the next step is to begin decorating the dress. There are, of course, many ways to do this. We will show you how one was decorated

Figure 47.

Figure 46.

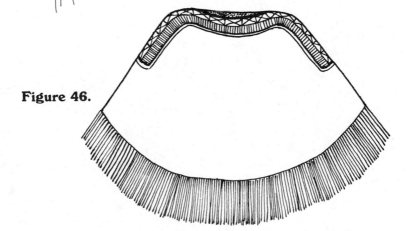

and, using your imagination, tailor your dress to suit your own taste.

Begin by sewing a beaded strip across the cape top so that it shows from the front. If you are using a two-piece cape, this will help to hide the seam. You may also sew another strip of beading across the back (Figure 46).

Next, you should decorate the body of the skirt and cape. This can be done by making buttons out of deer horn, drilling a 1/8" hole through the center of each, and attaching the buttons to the dress with leather strips run through holes in the dress material and then through the hole in the buttons. More color is added by placing large glass beads on the strips just below the buttons (Figure 47). The buttons are placed about 4" apart in rows on both the skirt and the cape. This finishes the dress. If you wish, however, you may continue to decorate your dress with more beading, fringe, tassles, or whatever you like.

The One-Piece Dress

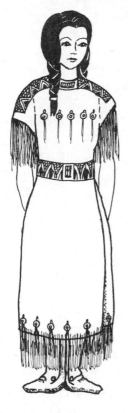

This dress is very similar to the two-piece outfit in the previous pages. The main differences are that this dress requires less sewing and uses larger pieces of leather. Like many other projects in this book, you may use leather or, if leather is not available, you can substitute white or buckskin-colored flannel or one of the new imitation leathers. Remember—while this project may be rushed through, it takes a lot of time and work to produce a good dress. So, don't begin unless you really want the dress and are prepared to expend the effort and hours necessary to finish the job.

You should begin by making a paper pattern in the form of a large T which would cover the subject from elbow to elbow and ankle to chin. For an adult, the top of the T, which forms the sleeves, should be about 12 inches wide (Figure 48). For a smaller person, this would, of course, be scaled down. The body of the T must be wide enough to allow the dress to be slipped on over the head after completion. The base of the T, that is the bottom of the dress, should be about 6 inches wider than the waist portion.

Lay the pattern out on the leather. If you do not have a large enough piece of leather to cut the pattern out in one piece, it will be necessary to sew pieces of leather together, adding separate sleeves or even top and bottom portions of the dress. The seam of the dress would be hidden by the belt at the waist. You will need to cut out two copies of the pattern.

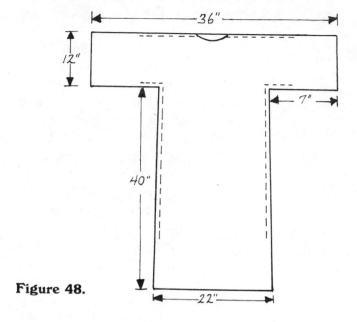

Figure 48.

Once the front and back pieces have been cut out, place them together with the finished sides facing each other. You are now ready to sew the two pieces together. A sewing machine is fastest, but the dress can also be done by hand. Sew across the top, being sure to leave a neck hole. Now sew the underside of the sleeves together, then continue on down the sides of the dress. Once this has been done, you can turn the dress right side out and begin cutting the fringe. This may be done with scissors, very carefully. Strips should be about 3/16" wide, though they can be slightly thicker or thinner depending on how good your nerves are. The hem of the dress should be fringed to just below the knee—approximately 12 inches. The sleeve should be fringed to just below the shoulder (Figure 49).

As with the other projects, the decorating will take as much or more time than the dress. It also offers you a great chance to make your dress distinctive from all others. You could begin with the bead or quillwork across the shoulders, or

could paint a design onto the dress; but, having gone to this much work, it would be a shame to cut corners at this stage. You may bead your design on a loom, then sew the beaded strip onto the dress. Or you may sew your beads directly onto the dress, using the lazy squaw stitch (see chapter on beading).

Once you have enough beadwork on the dress to suit your taste, you are ready to place other decorations on the dress. As with the two-piece dress, you may wish to place leather tassels with horn buttons on this dress, or you may choose to use shell circles instead (Figure 50). A third choice is to use small cowrie shells or even elk's teeth. The list is endless and the choice is yours.

The addition of a beaded belt will complete your dress and you can be justly proud of the end product of your hours of labor.

Figure 50.

Figure 49.

Cloth Dance Dress

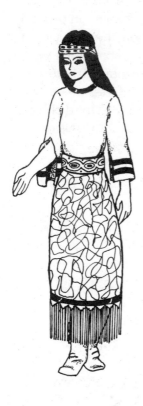

If you cannot afford the money or the time to make a leather dress, you may wish to make one of the modern cloth dance dresses. These are quicker and less expensive to make than the leather dress. They are also cooler in the summer and weigh much less than the bulky leather dresses. The cloth dress is also very beautiful in its own right.

Material for the dress should be a shiny satin cloth in a bright color. The apron should be a heavy brocade in a contrasting color, usually dark.

The dress itself is not difficult to make, being little more than a cloth tube with a round neck hole and sleeves. Begin by measuring the person who will be wearing the dress and make the tube large enough to slip over the wearer's head. You can, if you prefer, make a paper pattern to go by. Sew the sides, then hem the bottom and the neck hole (Figure 51).

The sleeves come next and are somewhat different from ordinary sleeves. They are sewn together for only the first three inches, after which they are hemmed along the edges and left open. Don't forget to hem the end of the sleeves as well (Figure 52). The sleeves should come down only as far as the mid-forearm.

Except for decorating the dress, the last things to be made are two small cloth tabs. These are made by sewing two pieces

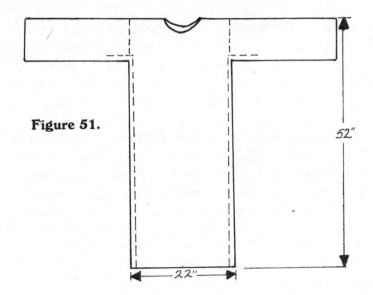

Figure 51.

52"

22"

18"

16"

Figure 52.

Figure 53.

24"

40"

Figure 54.

of scrap cloth together in a small, rectangular shape approximately 2" x 3", turning the rectangles inside out and sewing them in place against the seam on the inside of the hem (Figure 53). The authors do not know why these tabs are used, other than decorations, but nearly all cloth dresses have them.

Decorating the dress is quite simple and consists of 1/2" ribbons of cloth which are sewn on. One ribbon goes around the neck hole and two go around each sleeve. The choice of colors is up to you. Just be sure that the ribbons you pick look good with the color of your dress. It is not necessary to have all ribbons the same color. Some very attractive dresses have made use of two or even three colors of ribbons.

The apron is quite a simple affair and consists of a piece of heavy brocade cloth long enough to go from the waist to just below the knees and wide enough to wrap around the body without showing a gap (Figure 54). Hem the edges and sew on hooks and eyes and ties to hold it in place. The bottom of the apron should be fringed in the same manner as the dance shawls. The fringe, however, should not be so long as to hang below the hem of the dress.

The addition of an Indian-style belt will complete the outfit and is guaranteed to draw eyes and compliments.

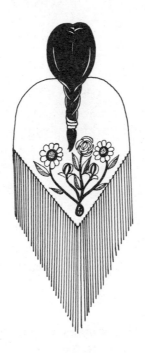

Dance Shawls

Dance shawls are an important item at almost any pow-wow. It's not uncommon to see a girl at a dance, wearing blue jeans and shirt, or perhaps an everyday type of dress, and the only Indian apparel on her will be her dance shawl. In many respects, this is the female counterpart of the male's ribbon shirt and many an Indian girl owns two or more shawls.

The shawl itself is not difficult to make, though you will find that access to a sewing machine will greatly speed up and improve the appearance of the finished product. Once again, adding the fringe and decorating the shawl will probably take more time than making the shawl itself.

It is generally believed that the shawl originated at Anadarko, Oklahoma in the late 19th or early 20th century and was, at first, worn only by the older women who watched very little time. Before you actually begin the embroidery, plan

72" x 72"

Figure 55.

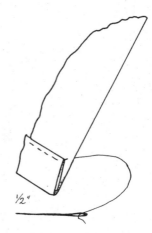

½"

Figure 56.

the dancing. As time went by, however, younger women began using the shawls. Today, they are both worn or carried folded over one arm while dancing.

You may use almost any type or color of cloth for your shawl, as there seems to be no standard material. You should bear in mind, however, the climate in which it will be used. Warm weather, for instance, would call for a shawl made of lighter material, whereas cooler weather would call for a heavier cloth. Keep in mind that you will need two yards of doublewide material so that you will wind up with a square of cloth, 6 feet on a side (Figure 55).

The first thing to do is to hemstitch the edges. These can be sewn by hand by folding a 1/2" flap of cloth along the edge, then folding it once more so that the raw edge of the cloth is on the inside (Figure 56). Take care when sewing to keep your hem straight and the stitching even. If you have access to a sewing machine with a hem-stitching attachment, this will make the sewing much easier and faster. Without the attach-

ment, the hem can still be sewn with the machine, but watch out for your fingers.

Technically, this finishes the shawl. In reality, however, there is quite a bit of work left. Decorating the shawl is next. This is done by embroidering a flower motif on the outside. Presumably, you could bead a design on the shawl, but the authors have never seen one with other than embroidery, nor any other design than the flower pattern.

It is not proposed here to instruct you in the art of embroidery. There are others far more qualified to do this than the authors; but, basically, embroidery is usually a series of parallel stitches of various colored threads which form the design. If you do not know how to do embroidery, you probably have a grandmother or aunt who can teach you in very little time. Before you actually begin the embroidery, plan your design very carefully. Dance shawls are worn doubled over into a triangle with the center point down the back and the end points over the shoulders and hanging in front.

Putting on the fringe is the last step in making the shawl. This should be done using braided nylon thread cut into 8-foot lengths. Thread one of these onto a large needle and begin on one corner of the shawl and run the doubled fringe through the shawl just above the edge of the cloth. Pull until just over half of the fringe is through. Now run the needle back through the shawl, right next to your original hole. Pull down until the two ends of the doubled fringe are even and only a small loop is left. Now you thread the ends of the fringe through the loop formed by the top of the fringe string. Pull the ends down until the loop is snugged down against the cloth. Cut the ends even. Move down one inch and put in another piece of fringe. Keep repeating this technique until all sides are completely fringed (Figure 57).

Many people choose to leave their shawls unknotted. This, in the opinion of the authors, is a mistake. Knotting improves the appearance of the shawl and adds to its value as well. To knot the fringe, simply take two threads from each

gathering. Add it to the two threads from the next gathering; then tie the four threads together in a simple overhand knot (Figure 58). Continue knotting until all gatherings have been divided and tied into knots. You must be careful to insure that the knots are evenly spaced and tied the same way. Spacing may be kept uniform by using a ruler or cardboard form to insure evenness. Knotting is done by rows. One row is the most common and three rows is considered best. You will seldom see a shawl with more than three rows of knots (Figure 59).

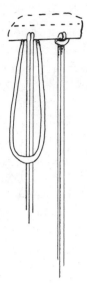

Figure 57.

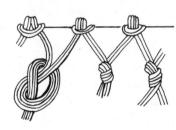

Figure 58.

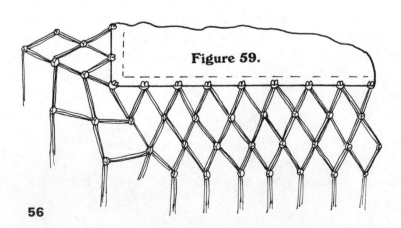

Figure 59.

Moccasins

No Indian's costume would be complete without a good pair of moccasins. To show up at a pow-wow in full feathers and regular shoes would be as awkward as going to a formal dance wearing hob-nail boots.

The making of a pair of moccasins is not difficult and should take no more than an evening of your time. The decorating of them, however, can require many hours, depending on how elaborate you desire the moccasins to be. Basically, there are two types of moccasins—the one-piece and the two-piece.

One-Piece Moccasin

The first type we shall discuss is the one-piece. Actually, this designation is incorrect, since the moccasin really consists of two pieces, the body of the shoe and the tongue; however, it has been known as the one-piece for many years and it is not proposed to change it here.

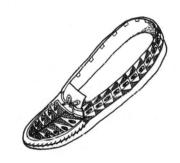

You begin the moccasins by making a pattern. This is done by placing a folded piece of paper on the floor and stepping on it. With the inside edge of your foot 1/4" from the folded side of the paper, trace the outline of your foot. Once this is done, you must trace another line 1/4" out from the outline of your foot. When the outline reaches the widest part of the outside edge of your foot, run the line straight back to the end of the foot. At the heel of the outline, measure one inch from the line and draw another line straight across, from the folded edge to the outer foot line (Figure 60). Cut out your pattern and unfold it; and,

Figure 60.

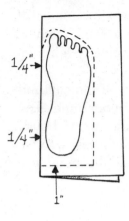

1/4"→

1/4"→

1"

Figure 61.

Figure 62.

Figure 63.

Figure 64.

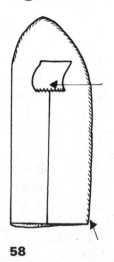

Figure 65.

on what will be the top half, draw a line 2 1/2" in length and 4 1/2" back from the point of the toe. At the center point of this line, draw another line extending from the first line to the back of the pattern (Figure 61). Cut these out.

Before getting out the leather, there is one more thing you will need. This is a piece of wood of about the size and shape of the front of your foot. It should be the same thickness and width, though you do not need to define the toes (Figure 62).

The choice of leather is up to you. It should be a fairly heavy leather, well tanned, and flexible. White or yellow buckskin would be the ideal choice but is hard to find, so use the best you can obtain.

Lay the pattern over the leather and trace around the pattern (Figure 61). Now take the wooden form you made. Wet the leather down thoroughly and stretch the upper toe portion over the form. Clamp or weight the leather in stretched position and leave until dry (Figure 63). This is very important but is seldom done. When it is not done, there is a very painful breaking-in period, since the toes of the moccasins will be too low and will put pressure on your big toes.

Once the leather is dry, cut out along the lines. Fold the two halves together, wrong side out, and sew them. Do not, however, sew the back. Now, you must cut the T-shaped line you drew on the top part of the moccasin. Cut a piece of scrap leather, 2 1/2" x 3 1/2", and sew this along the top bar of your T-cut for use as a tongue (Figure 64).

Place your foot in the moccasin and gather the excess material in back until the two sides meet at your heel. Mark both sides, then make a cut into each side of the leather towards the base of the heel. Now cut off the two back pieces at the mark, leaving only the lower flap. Sew the two pieces together, then turn the moccasin right side out (Figure 65). The end flap on the bottom may now be sewn in place. You may leave it square, round the edges, or taper them to a point. Whichever you use, the flap should be sewn to the outside of the moccasin. Should you chose not to sew it, tuck the flap

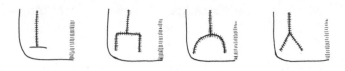

Figure 66.

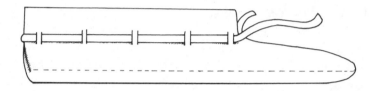

Figure 67.

inside the shoe (Figure 66).

The next step is to cut slits to run the leather thong through. These should be in sets 1/4" wide and 2" apart. The slits should begin at the edges of the tongue and continue around the foot below the ankle bone. Lace the thong in and tie it across the tongue (Figure 67).

This completes your moccasin. You need only turn down the side flap and they are ready to wear, unless you wish to decorate them.

Some hints: You may have trouble sewing with a needle. If so, punch holes with an awl. Setting your work on a block of wood will help when punching holes. Wetting the leather and stretching the top can be done after the moccasin is completed, but you will run the risk of the stitching pulling out. You may wish to remove the scarf (the shiny, outer layer on leather). This can be done by holding several hacksaw blades together and raking them across the leather.

Two-Piece, Hard-Sole Moccasin

Another type of moccasin once favored by many of the Plains tribes is the two-piece, hard-soled moccasin. This moccasin has a stiff rawhide sole and a soft buckskin upper. The type of rawhide used for the soles is the softer, flexible, creamy white rawhide originally made by the Indians—not the horny-looking material sold by most commercial leather com-

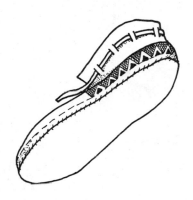

panies. The only place the authors know where to obtain this type of rawhide is from Indian craft supply houses who sometimes carry the material or from an individual who makes it. Should you be unable to obtain the correct kind of rawhide, you can make do with a fairly stiff commercial leather and use a softer, more supple leather for the upper portion of the moccasin.

Begin the moccasin by making the sole. First, place your foot on the rawhide and trace its outline, being sure to extend the toe section by about 1/4" inch to allow for curvature of the foot and sewing margin (Figure 68). When both soles have been cut out, you are ready to begin working on the upper section.

For the upper portion of the moccasin, you will need two pieces of leather about 8" wide and 1" longer than the length of the soles. Wet the leather and stretch it over a toe form as shown previously in the one-piece moccasin section of this chapter. Since there are so many foot sizes, it is impossible to give exact dimensions here, so you will have to use the trial and error method to find the proper width of leather to use. Once you have the proper width, cut out the leather in the shape shown and cut the T opening into which your foot will fit (Figure 69).

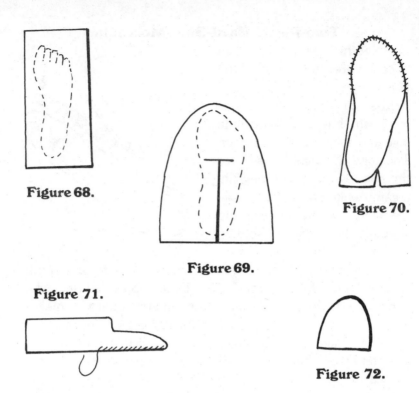

Figure 68.

Figure 69.

Figure 70.

Figure 71.

Figure 72.

Begin sewing by first wetting the leather and putting the two pieces together inside out. Start sewing at the toe and work about halfway back on each side (Figure 70). You will probably find it necessary to punch your holes first with a thin awl, then run your needle through those holes. If you do not have sinew, use a heavy waxed thread. Make your stitches fairly close, about 1/8". When you've reached the halfway mark, turn the moccasin right side out and continue sewing until the two sides meet (Figure 71). Then sew the heel seam. Next, cut a triangular tongue and sew it in place across the top of the T cut (Figure 72).

The last step is to cut small slits along the upper edge of the moccasin and run a leather thong through and tie it in front. The moccasin may now be worn, or you may wish to adorn your new footgear with beading.

Two-Piece, Soft-Sole Moccasin

The last style of moccasin is the two-piece, Woodland type which is considered to be the easiest kind of moccasin to make and is the type usually found in kits at leather stores.

You begin making this type of moccasin the same way as the other moccasins previously described—by making a tracing of your foot. You can make the tracing directly onto the leather, then mark an arc of about 2" around the toe area. At the widest point of the arc, extend the lines straight back to 1" past the heel mark (Figure 73). Cut a piece for each foot, then cut two ovals of leather the width of your feet and long enough to cover from your toe to your instep (Figure 74).

Begin sewing at the center of the toe area. Remember that the upper piece is about half the diameter of the lower so, for every 1/8" stitch made in the upper piece, you must make a 1/4" stitch in the lower piece and gather the edge (Figure 75). Occasionally, while sewing, check to make sure that the fit is good. After you have finished sewing the front part, it is time to sew the heel of the moccasin. This is done in the same manner as the one-piece Plains moccasin in the first part of this chapter. If you wish, at this point, you can put a board inside the toe of the moccasin and, using another board, pound the puckered seam flat. This is a necessity if you intend to bead the moccasin. The last step is to cut the vertical slits in the moccasin and insert the leather tie thong (Figure 76).

Figure 73.

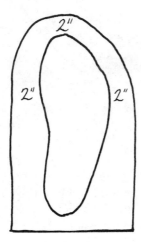

Figure 74.

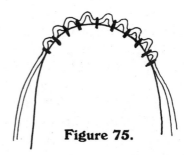

Figure 75.

Figure 76.

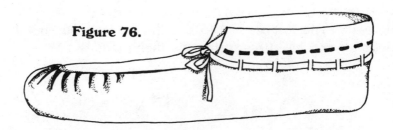

Beadwork

Certainly, among the most beautiful of Indian arts is the superb beadwork done by many different tribes. Though beadwork has been done by the Indians for many hundreds of years, it was not until the coming of the white men, with their small, brightly-colored glass beads, that this form of art gained popularity and quickly surpassed the quillwork from which it was derived.

You can find beads in department stores and craft shops, in various sizes and colors. The authors recommend 10/o as a good size with which to work. It is small enough to give good detail and a pleasing appearance, but is still large enough to allow working without undue difficulty. Colors most frequently used are red, white, blue, black, and yellow, though these are by no means the only colors that are or should be used.

Originally, the Indians used sinew from buffalo and other animals for stringing the beads together. Later, waxed thread was substituted for sinew, and today synthetics have mostly

65

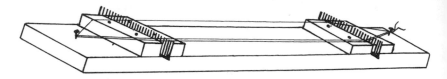

Figure 77.

replaced these materials. You will find dacron and polyester threads to be strong and very durable, as well as much easier to find than sinew.

A bead loom is a very simple item you will need for some projects. Once you have the parts, it requires only a few minutes to assemble it. You will need 2 combs, 10 nails, four pieces of wood approximately 1"x 2"x 4", and another piece of wood, either a 1x4 or a 2x4 which is one foot longer than the longest piece of beadwork you will be making (Figure 77). The authors recommend four feet as it will allow making longer items such as belts.

Beadwork is not difficult, but it does require lots of patience. So start by allowing yourself plenty of time when you begin a project. There are several types and styles of beading. We will discuss the easiest first—wrapped beading.

Wrapped Beading

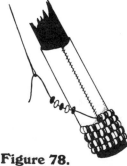

This type of beading is used to decorate round or cylindrical objects such as rattles, tomahawk handles, drumsticks—even fancy knife handles. Begin by covering the area to be beaded with leather or cloth. Roll the material tightly around the object to be worked; then sew the two edges together or you may, if you choose, use glue instead. Once the material is firmly around the shaft, you may begin sewing. Run the needle through the material for a short ways, far enough to hold the

Figure 78.

thread secure. Now place five beads on the needle and push them down to your starting point and lay them along the line you wish to work. At the end of the last bead, run the needle into the material. Run the needle around so that it comes out the same top hole that the thread went into, with 1/16" thread spacing in the back of the material. Then string five more beads and repeat the same steps (Figure 78). Do this until you have completed a circle. Once the row is completed, move upward enough so that you can begin the second row. This is done exactly like the first, except that the beads in this row should be staggered against the beads in the first row. Keep in mind that each row must be staggered with the prior row and you will need to change the color of the beads to form your design. When finished, run the needle back into the material and tie the thread off.

Flat Beading or Lazy Squaw

Flat beading is used in decorating such items as knife sheaths, moccasins, vests or any flat surface, and is done in basically the same manner as the wrapped beading, using what is called the lazy squaw stitch. To do this, first select the design you wish to use, then decide whether to apply the beads directly to the project or to a facing material which may be either cloth or leather.

To make the lazy squaw stitch, first anchor the end of your thread to the starting point of your work. Feed on the beads you want to string and lay them over to the position desired. If you are using a cloth facing, run the needle through the material. If you are working with leather, just run the needle into but not through the material (Figure 79). Once the first line is completed, move up just enough to do the next line. Continue this until the entire row is done; then move over and begin the next row until the entire piece is completed. If the beading is done on a facing, it may now be sewn in place on the project.

The number of beads used in the lazy squaw stitch can

vary from four to as many as
ten. The authors recommend
five as a good number, which is
easy to keep count with.

Figure 79.

Loom Beading

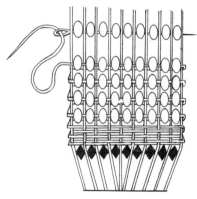

Figure 80.

This is perhaps the best
known form of beadwork and,
though slow, is not difficult. It
does, however, require a loom.
You can buy it or build your
own according to the directions
at the beginning of this chapter.

To begin, first string your
loom with the number of threads
needed for the width of the
desired project. This will require
one thread more than the
number of beads forming the
width of your work. Once the loom is strung, you will probably
need a beading needle which can be obtained at most
department stores. Thread the needle and weave it in and out
of your loom threads until you have about ten threads going
across the loom. These should be pulled fairly tight and
resemble a small piece of cloth. Now you are ready to begin
the actual beading.

This part is simple, but slow. Thread the number of beads
required onto the beading thread; then pass them under the

loom threads so that one bead falls between each thread. Hold your finger under these beads, then bring the needle over the loom threads and pass it back through the eyes of the beads. Move down to the second row and repeat the same moves (Figure 80). Keep doing this until the piece is finished. When all of the beads are strung, repeat the weaving process you did at the beginning. When this is done, remove the piece from the loom and tie all loose threads together to prevent unraveling. You may wish to sew a piece of cloth or leather to the ends as a further precaution against unraveling. You are now ready to use the piece by sewing it to a belt, headband, or whatever you wish.

Rosettes

Anyone who does Indian-craft will very soon have a use for beaded rosettes. Whether it is to decorate a headband, warbonnett, bustle, or whatever, rosettes add a touch that is not only beautiful but distinctly Indian as well.

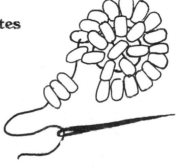

Figure 81.

To make a rosette, first select a piece of thin leather and draw a circle on it, being very careful to mark the exact center. Now draw a horizontal and vertical line through the center. Next dissect these lines so that you have four lines dividing the circle into eight equal wedges. Cut out the circle and, at this point, you may either hold the leather in your hand or stretch it on a small frame.

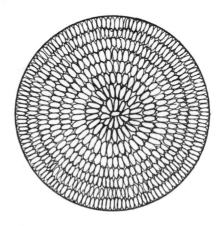

Begin with the center bead. Once it is sewn in place, you sew the first circle of beads in place. This is done by sewing one bead in place, then stringing two more on the thread. The third bead is sewn to the leather, as is the fifth and so forth until the circle is complete. Once the circle is finished, thread through all of the beads. This will help keep them smooth. When this is finished, go on to the next row and then the next until finished. All rows are done in the same manner as the first (Figure 81). When the last row is completed, run the thread into the leather in back of the rosette and tie it off. You may, if you wish, sew another circle of leather on the back to make the rosette look neater.

Picture Beading

Basically, there are three types of picture beading. The first is to sew each bead individually to the material. This is very tedious and is recommended only on smaller pieces. The second is the Lazy Squaw stitch already described. This stitch can be used quite successfully in conjunction with the first method by separately stitching the detail work and covering larger areas with the Lazy Squaw stitch. The third method is called appliqué beading and is used mainly for the flower and

Figure 82.

vine motifs of the Woodland Indians. This is done by using two needles and either two threads or both ends of the same thread. Lay out the design you wish on your leather and, at the start of the design, run your needles through the leather so that one comes out each side. On the work side of your leather, string the first two beads and lay them along the pattern line. Now run the second needle through the material. Loop it over the first thread and back through the leather so that it pins the first two beads down (Figure 82). String two more beads and repeat the same steps. Keep doing this until you have completed your design.

Net and Edge Beading

Edge beading is often used on shawls and robes to add an extra touch. Net beading is used to make collars, pouches, and other items on which a lace-like effect is desirable. These are not difficult and the illustrations are self-explanatory (Figure 83). Several different styles are included, though the methods of construction are basically the same.

Figure 83.

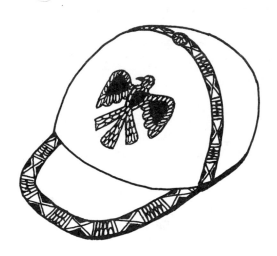

Beaded Baseball Cap

One of the more popular Indian items of today is the beaded baseball cap. This is not a difficult piece to make and several evenings of beading should see it completed. If you are a fast worker with some experience in beadwork, it should only take you about three hours.

Designs vary greatly with the personal taste of the worker. The most common design, however, is a band going around the bill and up both sides to the top button, which is usually beaded as well.

To do this type of beading, first bring your needle and thread through from the underside of your cap so that it comes out at the point at which you have decided to start. String six

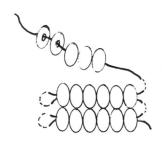

Figure 84.

beads onto your thread and lay them in place. Now, run your needle through the cap next to the beads. Double it around and bring it back through the cap. Next, run the needle through the cap at the point where you will be starting your next row and repeat the same steps (Figure 84). You will, of course, vary the bead color to change the design.

Continue the beading until you have finished the cap. Care taken in the beading will pay off in the finished product. Be extra careful to see that your line of beads is straight and that you maintain the same number of beads per line. Also, watch that you do not get the wrong colors in the line. The top button of the cap can be beaded by using the same method used to make rosettes.

Most of the beaded hats you will see are of the cloth-over-foam type with an adjustable back. This is probably due to the fact that this is virtually the only type of baseball cap available today.

Quillwork

Quillwork was the forerunner of beadwork. It is considered more difficult and more expensive to do. Should you choose to do some of this work, you will find that it draws much more interest among knowledgeable persons than beadwork. Quillwork is not easy, but we believe that the work is more than outweighed by the beauty you will create.

The first and perhaps hardest part is finding materials. Unless you live in porcupine country, or have a friend who does, see the materials chapter in this book. Quills come in various sizes, from one to five inches. Unless you are very lucky, your quills will probably range from two to three inches. They should be separated by length and thickness. Be very careful when working with quills. They are quite sharp and, once stuck in flesh, are very difficult to remove. Also, no matter

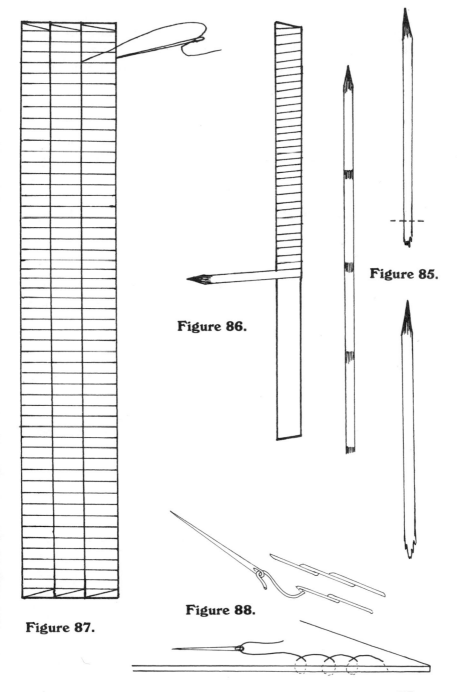

Figure 85.

Figure 86.

Figure 87.

Figure 88.

how hard you try, you will find that loose quills turn up in the strangest places. This can be minimized by working on a hard surface, with a wood or tile floor under you, and checking your body and clothes before leaving the work area.

The simplest method of quillwork is to cut 1/4" strips of thin leather the length of your work and wrap the quills around the strips. Begin by cutting the base off of the quills and inserting the point of the next quill into the cut section of the first quill (Figure 85). When you have about 12 to 14 inches of quill, it should be flattened. This can be done by pressing it with a spoon or the back edge of a knife. Once flattened, you can begin wrapping it around the strip by first tucking the end of the quill under your work so it won't slip (Figure 86). When you run out of prepared quills, make up more and continue until finished. Some difficulties you might experience are the quill sections coming apart. This can be corrected by placing a touch of glue on the tip and reinserting the quill. Another problem, especially in larger quills, is brittleness. This may be overcome by soaking the quills in water for about an hour.

Once all of the strips have been wrapped, they must be sewn onto the project they will be decorating. This is done by laying the strip against the material and, bringing the needle through the material from the underside. Lay the thread over the strip and run the needle through the material again (Figure 87). Now move about 1/2" inch down the strip and repeat the process. When finished with the sewing, tie the thread off and, if you wish, you may color a design onto the quills.

There are quite a few differences of opinion on how to color quills properly. Many do not color the quills at all, being quite content with their natural tones. Others insist that the quills must be dyed, using natural dyes, while still others contend that modern dyes are quite acceptable. If you use dye, it must be done before the quills are cut and wrapped. You must be careful to change colors on the backside of your work so the change will not be apparent on the front. Another method is to use colored ink with a small brush and a steady

hand. The advantage of using this method is that it can be done after the quillwork is finished. This eliminates the possibility of the strips slipping while sewing, which results in your design not lining up properly.

Other and older methods of quillwork are known as wrapped, folded, and plaited. They all have certain advantages over using strips but the quills must be soaked first and require much more time to work. Most of these types of quillwork use the two-thread method of sewing. It is recommended that you use the overlap stitch in this work. This consists of sewing a line in place with your thread and backstitching 1/8" to 1/4" so that you don't have a bare space in your material which will cause a gap in your quillwork (Figure 88).

Wrapped Quilling

This is much the same as strip quillwork except that the quills are wrapped between two threads instead of around a leather strip. A distance of 1/4" to 1/2" between the threads seems to be the best working space. This type of quilling was used for breastplates, moccasins, and line design (Figure 89).

Folded Quilling

Folded quilling produces an interlocking triangle design which is accomplished by bringing the quill over the thread. Then, instead of going under the second thread, bring the quill out and over the second thread. Then go back to the first

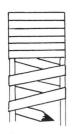

Figure 89.

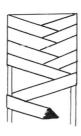

Figure 90.

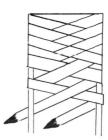

Figure 91.

thread, using the same method (Figure 90). This is used to cover large areas such as cradle covers.

Plaited Quilling

Plaited quilling is done using two quills at once and produces a most attractive diamond design. Begin with two quills going in opposite directions. The first quill goes over both threads; the second quill goes under both threads, but goes over the first quill (Figure 91). To keep from getting confused, always count the quill on your left as the first quill. Keep repeating these moves until you have finished your piece. This type is quite frequently found on shirts and leggings.

Pipestem Quilling

Another method of quillwork is a variation of plaiting in which the quills are plaited onto two pieces of sinew (or string) and then attached to the item being decorated. This type of quillwork was originated by the Sioux and was normally used to decorate round objects such as pipestems and tomahawk handles, though it can also be used on flat work as well. This style of quillwork looks very attractive and is not difficult to make. By changing the colors, you can create almost any design you choose.

Begin by preparing your quills the same way you would for any other quillwork. Next, stretch two strings or pieces of sinew, if you have them, between two tie points. The strings should be about 1/8" apart and you will need a spreader to hold the strings apart while you are working them.

Begin your plaiting at the bottom of the two strings. Insert the first quill between the two strings so that the point of the quill goes behind the left string. Now fold the quill around the right string so that it laps behind the left string. Next, fold the quill around the left string so that it passes under the quill point and comes up between the two strings and points to the right (Figure 92). Now bend the quill around the right string and

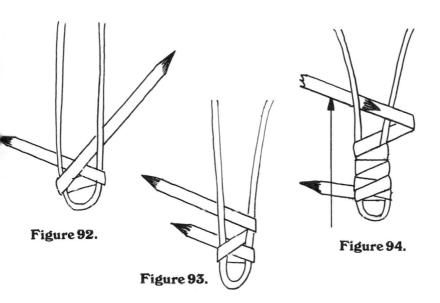

Figure 92.

Figure 93.

Figure 94.

between the two strings again, going to the left this time (Figure 93). Bring the quill around the left string and repeat the last steps (Figure 94). When you near the end of the quill, stop with the end of the quill passing between the strings and pointing to the right. To begin a new quill, put it on the end of the finished quill and repeat all of the steps in the same manner as previously described (Figure 95). When you have completed the strip of plaiting, pass the end of the quill between the two strings and under the last fold of the quill (Figure 96).

Care should be taken to get equal tension on all the wraps of the quills or the thickness of your strip will vary. Once completed, the strip can then be sewn to whatever piece you are working on.

This method of quilling has several advantages. One is that it is fairly fast and the width of the plaiting can be changed from very thin, using strong thread, to quite thick by using light cord. Also, the plaiting can be made any length you wish. Another advantage to this method of quilling is that you can use other types of weave such as the double weave described earlier.

79

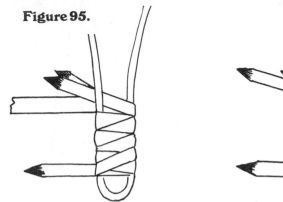

Figure 95.

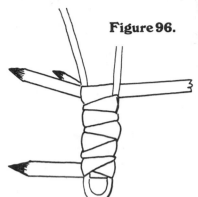

Figure 96.

Other types of quillwork are: the spotstitch, which produces a series of small, opposing triangles (Figure 97); the single thread stitch in which the quill is merely wrapped around the thread and flattened into place; and the rosette which uses the wrapped quill process with the two threads running in circles instead of a straight line (Figure 98). There are, of course, other methods of quilling. Entire books have been written on the subject. This chapter will get you started, and where you go after that is up to you.

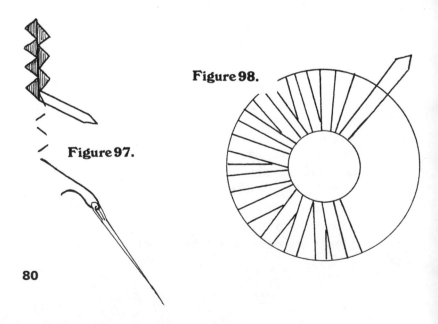

Figure 98.

Figure 97.

Some helpful hints: Before you attempt to dye quills, thoroughly wash them in warm water and detergent. This will remove the natural oils and allow the dye to better penetrate.

In the old days, women who did quillwork usually kept the quills handy by holding them in their mouth. This has several advantages such as keeping the quills moist and pliable while allowing them to be close at hand, even while both hands are busy. Should you elect to use this method, there are several precautions to take. First, make sure that the hard, sharp ends of the quills point outward from your mouth; second, be careful when reaching for a quill; and, third, for Pete's sake, don't swallow any quills!

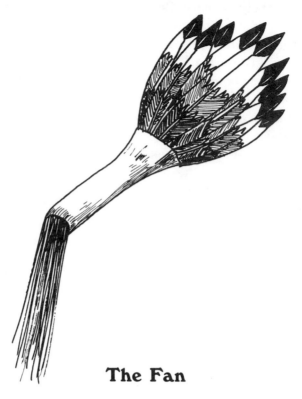

The Fan

While not a necessity for dancing, the Indian fan will often add that certain touch which can raise a costume from the status of good to very good, or even excellent. While used by both sexes, the fan is most often found adorning the women's costumes.

There are several different ways to make fans which we will discuss here. The first type of fan is that made from a pair of bird wings. This is not a difficult type of fan to make—indeed, the hardest part will be obtaining the wings. These should be from a medium-size bird with colorful plumage. A pheasant would be a good choice, as would a quail, or the wings from one of the more colorful breeds of chicken. If you know someone who hunts or has a small farm, you might be able to get the wings from them.

If the wings are still fresh, they will need to be dried. This is done by storing them in a cool, dry place that is free of insects for about a week. Before you dry the wings, they should be placed in position first. You may want them fully open, halfway open, or closed. The setting of the wings is your choice; however, bear in mind that the larger the wings, the more they should be closed.

When the wing is ready, it is a simple matter to attach it to a flat piece of wood for use as a handle. You may use one wing or two, depending on whether it is large or small, opened, or folded. The handle may be any flat stick about 1/4"x 1"x 6". A stirring stick from a paint store will work quite well. Attach the wing or wings to the handle by either gluing or tying it on with string (Figure 99). Tying is usually better, since you may wish to redo the fan later on.

Once the wing is attached to the handle, you will need to cover the handle with leather. Use two pieces of soft, stretchy leather. The first piece goes around the last inch of the handle, leaving about 6" of loose leather dangling. This is to be cut into fringe (Figure 100).

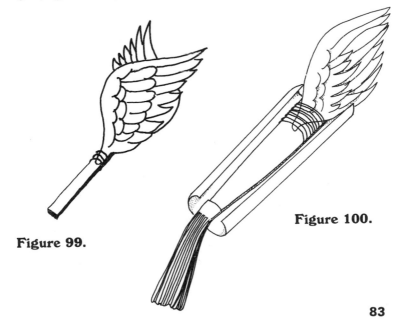

Figure 99.

Figure 100.

The second type is the standard Indian flat fan. It takes more work but it is easier to obtain feathers for this type fan. You can, if you wish, use other feathers; however, imitation eagle feathers are the most common. You will need seven feathers, three left, three right, and one for the center which can lean either way but will have to be heated and straightened as much as possible. The other feathers should be straightened somewhat, though they need not be absolutely straight. (See section on straightening feathers in warbonnet chapter.)

Figure 101.

Figure 102.

Next, you need to make the handle. This is cut out of a piece of wood which can be from 1/2" to 3/4" thick (Figure 101). The handle should be round or oval at the bottom with a 1/16" recess cut in the bottom half of the handle. The top of the handle should fan out to three inches across. Using a drill, make seven holes 1 1/2" deep, equally spaced across the top of the handle. Next, using a file or sandpaper, round off all sharp edges, except the bottom 1/2" where the recess is (Figure 102).

You are now ready to put the feathers in place. The quills are inserted in the holes which were drilled into the top. If the quills are too long, cut the ends off of them so that all of the lower portions of the feathers are even. Be sure that you have the left and right-hand feathers in their proper positions. Now you need to trim the top of the feathers so that they are symmetrical. Do not cut the ends off flat; instead, round them so that the feathers look natural. You may now glue the feathers into position.

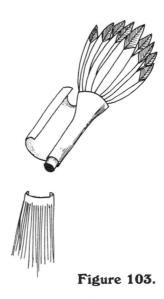

Figure 103.

When the glue is dry, cut a piece of soft leather 7" long and wide enough to go around the handle. Fringe it to 1/2" of the top edge and glue it around the recessed area in the handle (Figure 103). After the fringe is in place, cover the handle with leather by stretching it while wrapping it around the handle, then glue the leather in place. When the glue is dry, the fan is ready for use.

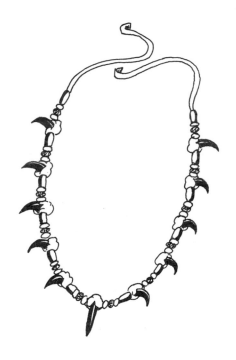

Bear Claw Necklace

One of the most prized items an Indian could possess was his bear claw necklace. In addition to being a striking piece of jewelry, it was also a medal attesting to the warrior's courage and skill.

While not difficult to make, you may experience some problems in gathering the bear claws. Unless you have a close relative who has been or is about to go bear hunting, your best bet is to look around the gun shows, flea markets, and Indian shops in your area. It would also be a good idea to buy a copy of *Boy's Life Magazine,* as several of the Indian craft suppliers advertise in that publication.

Failing to find any bear claws from any of the above sources, you can get plastic replicas from some of the leather stores, or you may elect to carve your own out of wood.

Carving your own bear claws is not difficult. Obtain a piece of 3/8" basswood from your local hobby shop and draw the outline of the claws on the surface of the wood, then cut them out with a saw. Once cut, carve them into shape with a knife and sand smooth (Figure 104). Then paint the back of the claw red and the claw itself, black.

The final step is to drill a hole through the claws and string them with large beads as spacers. An alternative method is to make spacers of fur by folding and sewing a 2" square of fur together to make a cylinder (Figure 105). Normally, ten claws make a necklace, although sometimes as many as twenty or more claws may be used. After painting, coating the claws with wax gives them a dull shiny luster, adding to their realism.

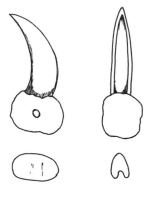

Figure 104.

Figure 105.

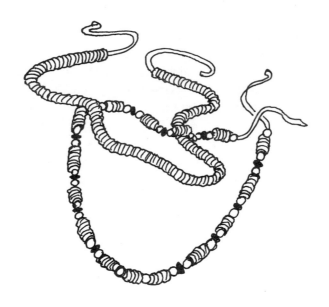

Crinoid Stem Necklace

One of the most unusual Indian necklaces you can make is the crinoid stem necklace which also happens to be one of the easiest necklaces to make.

Crinoids were ancient plant-like animals which lived in shallow seas hundreds of millions of years ago. These crinoids floated on the surface and were connected to the bottom by stems composed of thin, disk-like sections connected one atop the other. These plants died ages ago. Their remains became fossilized and, today, crinoid stems are very common. Nearly every rock shop has some you can get quite inexpensively. Or, you can call the geology department of your local college or university and someone should be able to tell you if crinoids are found in your area.

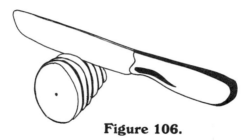

Figure 106.

Once you have your stems, take a kitchen knife and place it along the joint line of two disks (Figure 106). Tap the knife lightly with a hammer. The disk should split off from the main section of the stem, however some crinoid stems shatter instead. If this happens cut them with an X-Acto saw or hacksaw. When the disks are separated, drill the center out by using a thin awl or drill bit. Do not use a power drill. Once the holes are in the disks, string them to make the necklace. You may wish to use other types of beads with the crinoid stem disks for a more striking necklace.

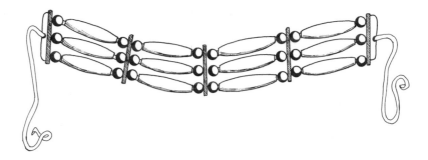

Hairpipe Choker
& Woman's Bone Breastplate

While the hairpipe breastplate of the man may be considered a form of armor as well as decoration, the woman's breastplate is strictly ornamental. While not difficult to make, you should take as much care with this project as you would any other. Hurried or sloppy workmanship will reflect badly on both you and the art of Indiancraft.

As with the man's breastplate, locating hairpipe may be your hardest problem. The hairpipes used for the woman's breastplate should be smaller than those used on the man's—2 1/2" to 3 1/2" are good sizes.

Begin by making a choker using small hairpipe beads 1 1/2" to 2 1/2" long. The choker is nothing more than three strands of hairpipes strung together with large glass or wood beads spaced between them. These beads will add color. Attach leather spacers between the beads to join the strands. Use leather thongs to tie the choker in the back. You may stop at this point and have a very nice choker to which you may wish to add a shell gorget as further decoration (see index). Or you may continue by making the breastplate.

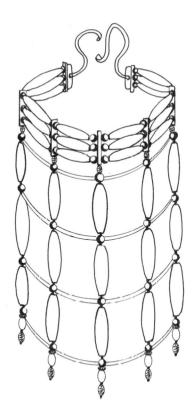

Figure 107.

The breastplate is made by stringing hairpipe beads vertically from the leather spacers on the choker. The vertical hairpipes used should be longer than those used for the choker—3 1/2" or 4 1/2" are good lengths. Leather spacers may also be used to keep hairpipes in line (Figure 107). You may also wish to add large, bright wood or glass beads for an extra touch of color. The woman's breastplate should hang loose at the lower end, unlike the man's breastplate.

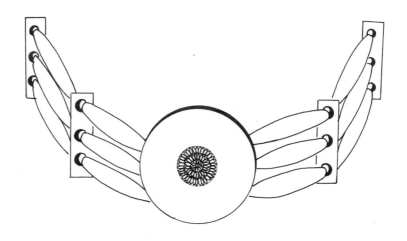

Shell Gorget

A shell gorget can add that extra touch of realism to your necklace, choker, or Indian costume. The gorget is easy to make and requires only a few tools. Obtaining the shell will be your first task. If you live near the coast, this should present no problem; living inland could make your acquisition of the shell a bit more difficult. Good places to look for shells are flea markets, garage sales, lapidary and gift shops. Almost any kind of shell will work, provided it is large enough. Many people prefer abalone because of its rich colors.

Once you have your shell, mark a circle in the flattest part of it. A 2- to 3-inch gorget is a good size, though you may

make it larger or smaller, as you wish (Figure 108). Using a coping or jig saw, cut the disk out. Then, take a file and smooth out the rough edges left by the saw. Use a hand drill to drill two or three holes in the center. Once this is done, the gorget is finished and you have only to mount it by running a leather thong through the holes and tying it to your necklace. You may also attach a beaded rosette in the center of the disk.

Figure 108.

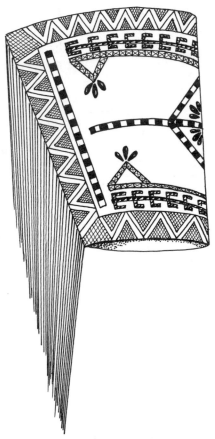

Cuffs

Cuffs were copied from the guantlets worn by the U.S. Cavalry. The Indians decorated the cuffs with beads and sometimes quillwork so that the troopers' plain guantlet became a work of art on the arm of his Indian counterpart. As with many Indian crafts, decorating the cuff will take considerably longer than the actual construction of the cuff.

To make your cuffs, you will need four pieces of leather—two pieces 10 1/2"x 6" and two pieces 6" square. The leather used should be soft, supple and cream- or buckskin-colored.

Mark and cut the two larger pieces in an arc as shown in the drawing, keeping in mind that you must be able to fit your hand through the cuff when it is sewn together. It should also not be too loose or it will fall off while you are wearing it. Fold the cuff leather and sandwich the square piece of leather between the two edges of the cuff. All that is left to do now is to sew the pieces together and cut the fringe.

With the cuffs finished, you may begin decorating them by using the lazy squaw stitch described in the beading section of this book.

Figure 109.

Child's Tipi

Originally, we planned to give instructions for making a real tipi. A tipi, however, is a great deal of work and expense requiring, among other things, a commercial sewing machine. The authors urge anyone interested in making their own tipi to obtain a copy of *The Indian Tipi* by Reginald and Gladys Labin. This excellent book quite thoroughly covers the subject of building and erecting tipis, as well as the history and lore of the subject.

What is proposed here is to give instructions for making a child's tipi which you will find to be much quicker, easier, and less expensive to make and will provide one or more youngsters many hours of enjoyment.

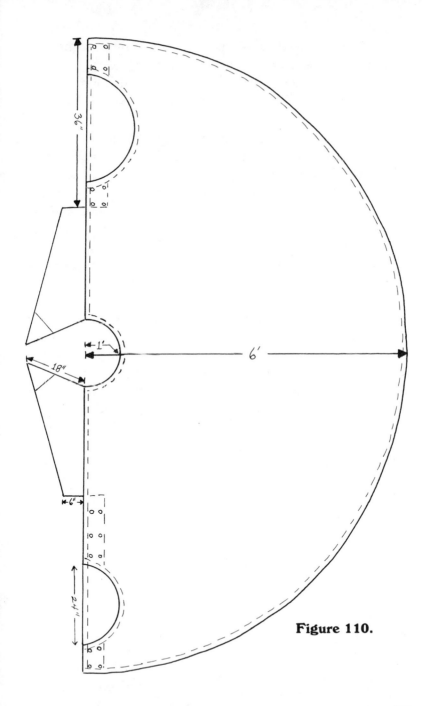

Figure 110.

For this project, you will need two used bedsheets, a sewing machine, and ten poles about 8 feet long, as well as some paint or magic markers with which to decorate the tipi. The sheets used should be white or buckskin-colored and, while used, should be in reasonably good shape. You may, of course, use new sheets. It may be possible to obtain used sheets at a reasonable price from your local hospital, hotel or motel. For your tipi poles, you can sometimes find seven- or eight-foot dowel rods one to two inches thick at your local lumber yard. These, however, are quite expensive and you may decide to use 1x2's or 2x2's instead. Another substitute is to use bamboo or cane fishing poles. These are usually about ten feet long and sturdy enough to provide the support you need.

Begin by sewing the two sheets together, then cutting out a big half circle and a small inner half circle as shown (Figure 110). Hem all free edges of the material. Using the scrap material, cut the flaps and sew them in place. Next, using more scraps, cut reinforcing panels for the front of the tipi. If you have a sewing machine with a buttonhole attachment, use it to make large buttonholes to pin the two sides of the tipi together. If you don't have a machine, you will need to cut the holes and sew them by hand.

Once the outer covering is completed, there is little to do except decorate and erect the tipi. You may wish to spray the fabric with a waterproof coating if you intend to leave it outside for an extended period of time.

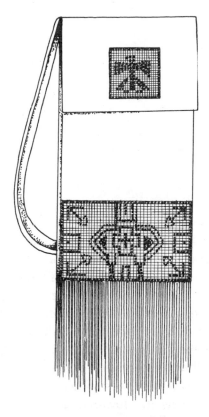

Pouches & Bags

In the old days, one of the most useful items made by the Indians were the often beautifully decorated pouches and bags made to hold almost anything from pipes and tobacco, to food, or flint and steel. With the coming of pockets, pouches began to disappear and, today, they are rarely seen, even at pow-wows. But when they are seen the pouches are appreciated all the more because of their rarity.

There are many sizes and shapes of pouches, only a few of which we will be able to cover in this book. The first will be the Plains tobacco pouch. Originally, buckskin would have been used. Now, however, a good, soft, white leather is an excellent substitute.

Figure 111.

You will need two pieces of leather. The first one, 12"x 18," and the second, 11 1/2"x 10"—or you can use two pieces, 5 3/4"x 10" (Figure 111). Take the large piece and lay it on a flat surface. The side which will be the outside should face upward. Now take the smaller piece (this will become the fringe) and fold it over so that the finished side is on the outside. Lay it on the first piece (Figure 112). Then fold the first piece over so that the second piece is sandwiched by the first piece, leaving only the edges showing at the lower edge.

Now you must sew the lower edge. This will probably need to be done by hand. Be sure your needle goes through all four layers of leather. After you have finished the lower edge, turn the pouch inside out and check for loose stitching (Figure 113). Once satisfied with the stitching, reverse the piece again and stitch up the side until you are 3" from the top (Figure 114). Stop at this point and tie off the thread. Then cut off one side of the unsewn piece. This will be a piece 3"x 6". The other side will be used as a flap for the opening.

At this point, you must decide how you intend to use the pouch. You can leave it as is, or sew loops to the back to wear it on a belt, or you can sew a long strap to it and carry it over one shoulder. Usually, men prefer to wear one at the belt, while women like the shoulder strap. If the pouch is not going to be worn, leave it as it is and go on to decorate it.

100

Figure 113.

Figure 112.

Figure 114.

Decoration can be done using either quill or bead work and follows a somewhat traditional motif. From the start of the fringe, the bag should be solidly decorated from one-third to one-half of its length. From there up, strips one- to two-inches wide should be decorated on one or both sides; and, lastly, the top flap should be done. This decorating serves a dual purpose—stiffening the bag as well as beautifying it.

There are other designs, but all of them are variations on this one. You could, for instance, make the pouch out of one piece of leather—should you have a piece large enough. You could make the pouch wider, or shallower, or deeper to use as a bow case. You could also put a drawstring around the mouth or round off the bottom. In short, the pouch or bag should be tailored to fit your needs because you will be the one using it—so design it so that you will be happy with it.

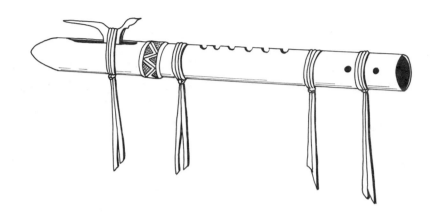

Indian Flute

Hauntingly beautiful are the only words which can be used to describe the music produced by an Indian flute in the hands of a master player. Of course, not everyone can be a master of the flute but, with practice, almost everyone can become a competent player.

First, one must have an Indian flute. You could buy one, but such flutes are quite rare and very expensive, averaging about two hundred or more dollars. If you elect to make your own, then read this chapter very carefully, as the authors are indebted for much help in its writing to Woodrow Haney, who is considered by many to be America's premier Indian flute maker.

Almost any wood can be used to make your flute, though redwood and cedar are considered best. Also bear in mind that the softer woods give a mellower tone, while the harder the wood, the sharper the tone. Whichever type of wood you choose, you will need three pieces—two pieces of which are at least 3/4" thick by 1 1/2" wide and 22" long for the body of the flute, and one piece approximately 1" thick by 2" wide and

up to 6" long, depending on what you wish to carve on it. All wood must be clear, straight-grained, and free of any knots, cracking, or warpage.

Before you begin making your flute, study the drawings very carefully and follow them as closely as possible. The actual flute itself consists of only four parts—the flute, which is two parts, upper and lower; the nest which is the flat piece of wood or metal that goes atop the flute; and, lastly the bird, (also called the saddle) which is the carving that goes on the nest.

Figure 115.

Begin the actual construction of your flute by marking off the lines as indicated above on your two long pieces of wood (Figure 115). Then, gouge out two half-round channels in each piece. Be very careful not to cut through the retaining wall between the channel halves or cut too deeply into the wall of the flute and risk punching a hole in it. A good idea is to make a cardboard templet 7/8" in diameter to use as a guide (Figure 116). Once the channel walls have been gouged on both pieces, sand them smooth and place them together to inspect for a good fit with no gaps. Do not glue the two pieces together yet.

Figure 116.

Now is the time to make the holes in your flute. Traditionally, these holes are burnt through with a hot iron rod; however, if you wish, you may drill them first, then burn the edges. You will need to make twelve holes in all (Figure 117):

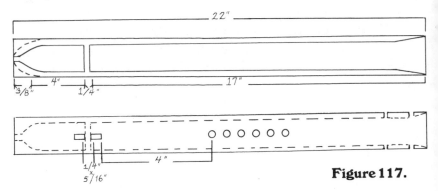

Figure 117.

1. Two square wind passage holes, 1/4" by 5/16", 1/4" apart on each side of the retaining wall. To make these holes, drill 1/4" round holes, then square them up with a small, sharp knife. Later, you will need to bevel the leading edge of the second hole as shown in the diagram (Figure 118).

2. Four inches down from the second square hole, drill a 1/4" hole. This will be the first of the six finger holes. These holes are not drilled in a straight line but in a slight arc to the left, enabling the fingers to fit more comfortably over the holes. Spacing for the finger holes varies with the flute maker, from 1" to 1 1/2" with 1 1/8" being considered the best all-around spacing.

3. The four remaining holes are called the "four winds" or, sometimes, the "four-corners" holes for the four corners of the world. These holes may be round, square, or rectangular, as you choose. The holes may also be placed one on each side of the flute, with one on the top and one on the bottom. All holes should be 1/4" and 1" back from the end of the flute. Another method is to make a hole on each side of the flute, 1" from the end, and, the other holes, 2" back from the first pair.

Figure 118.

Now that the holes are finished, it is time to round off the outside of the flute. First, however, you must glue the two halves of the flute together. Use a good-quality, waterproof, wood glue and clamp the two parts together. Be careful not to misalign the two halves and do not clamp them too tightly as you could crack the wood. Once the glue has thoroughly dried, round off the flute until it is smooth and even. This can be done with a sander, plain sandpaper, a file, or, if you are very careful, with a knife. Begin with the corners and work them down until you have an even thickness all around.

Next, you need to make the roost, which is the flat area on top of the flute (Figures 118, 122). The roost can best be made with a piece of sandpaper and a sanding block. A width of 3/4" by 4" long is plenty of space for a good roost. Be careful not to cut too deeply and weaken the top of your flute. Once you have finished the roost, you must bevel the leading edge of the second hole.

After the main body of your flute is finished, the next step is to carve the bird. If you do not feel confident enough to carve a figure, you can make a saddle, as drawings and dimensions for both are included here (Figures 119, 120). When this piece is finished, sand it smooth and be sure to make the bottom flat. Then give both the bird and the flute two or three coats of boiled linseed oil. Allow each coat to dry thoroughly before applying the next. Once the final coat is dry, rub the pieces down with steel wool until they are smooth and shiny.

Only one piece remains to be made—that is the nest or flat piece which goes between the roost and the bird (Figure 121). This may be made from metal, hardwood, or even pasteboard or fiberboard, though aluminum is most frequently used. The nest needs to be 1/64" thick, 3/4" wide by 2" long. In the center of the nest, cut out a rectangle 1/4" wide by 1 1/8" long.

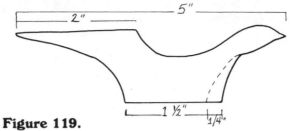

Figure 119.

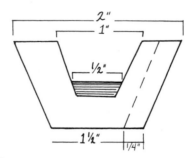

Figure 120.

Figure 121.

Figure 122.

When all pieces are finished, assemble them as shown in the drawings and tie the pieces together with a leather thong. Use other leather thongs as decorations.

You must now find the point of adjustment for maximum volume and tone quality. This is done by sliding the nest back and forth between the flute and bird while blowing on the flute until the best tone is produced (Figure 122). It may then be necessary to retie the thong to hold the pieces in place. This adjustment will complete your flute, unless you wish to decorate it further, perhaps with beadwork.

Bullroarers

Bullroarers are perhaps the easiest of all Indiancrafts to make and, for younger children, they certainly are the most fun. They were used by most of the Plains tribes and originally were held sacred as representing the voice of the wind.

To make your own bullroarer, get a flat piece of wood 10" to 12" long, 2" to 3" wide, and 1/2" thick (Figure 123). Cut it into an oval shape, then bevel the upper edges until you have a rounded top over which the air will flow the same way as it does over an airplane's wing. Drill a hole in one end of the wood and tie a string through that hole. Three to four feet is a good string length to use.

Figure 123.

Now whirl your bullroarer around on the end of your string. The roarer will make a low whirring sound which will get louder as you go faster.

Bullroarers look better if they are painted. Thunderbirds and lightning designs are very appropriate and are not hard to do—or you can create your own patterns. The bullroarers can also be made in other sizes and shapes up to two feet long. The longer they are, however, the narrower they should be.

Making your own bow is not difficult, though it is a slow and rather exacting process. The first step, which is the most difficult and most important, is obtaining the correct wood. The best woods, in order of their desirability, are Osage orange (also called mock orange, hedge apple, horse apple, and bois d'arc—bowdark in America); yew comes after that; then lemon wood, oak, hickory, ash, juniper, cedar, cherry, and mulberry are other woods which the Indians used and which you may be able to find in usable form. The wood should be about 5 feet long and about 2 inches thick. It *must* be straight-grained and free from knots; otherwise, your work will be in vain as the bow will probably break the first time you draw it.

The type of bow shown here is a Cherokee type which, over many years, has proven to be an

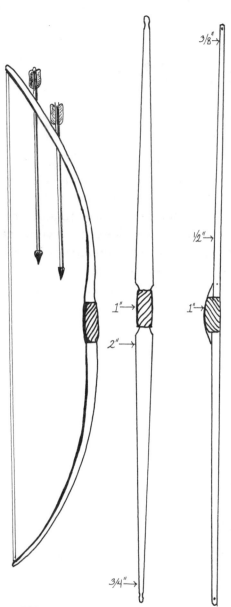

Figure 125.

Figure 124.

excellent design. If you are careful, you can cut your bow out of the wood with a saw. Remember, the outer curve of the growth rings must be the back of the bow (Figure 124). This is every bit as important as using wood with straight grain.

Follow the dimensions given and very carefully work the wood down, stopping occasionally to check that your work is even and smooth. Take the wood down slowly and remember that, once the wood is taken off, it's impossible to put it back on. The figures given in the drawings should not be taken as exact. The length may easily be as much as 6" longer or shorter. Width may vary a little but should not stray far from the original dimensions. Thickness must vary in order to control the strength of the bow.

When your bow is nearing completion, you must check the bend. To do this, grasp the ends and pull down gradually. The arms of the bow should bend evenly. If one part bends more than the others, the rest of the bow must be shaved down to where it bends evenly. Do this very carefully; otherwise, you will wind up with a bow that is so thin that it may only have a 10-pound pull. When testing, it is only necessary to draw the bow about halfway.

Once the bow is worked down to your satisfaction, sand it smooth and rub boiled linseed oil into it very thoroughly. If the bow was made from green wood, it should be stored away in a warm, dry place to season for at least three weeks. Two months would be even better.

The bow can now have a handle put on it. This can easily be done by gluing a piece of leather around the middle of the bow and wrapping the ends of the grip with narrow strips of leather which can be held in place with small tacks. You can buy the bowstring or make one of Dacron string waxed with beeswax.

A few further notes are now in order. Occasionally rub

your bow with linseed oil; never leave your bow strung when not using it; and store it horizontally. Never lean it upright in a corner. One last word—never string a bow backwards. Believe it or not, many people will do this.

Bow tip showing string groove.

Arrows can be made from the straight shoots of most trees—smoothed down and straightened, where necessary, by heating them. You may use commercial heads or use blunt wooden heads, such as the Indians used for birds. Fletching can be made from various types of feathers. Split and with the quill trimmed off, the feather may be glued in position (Figure 126).

Figure 126.

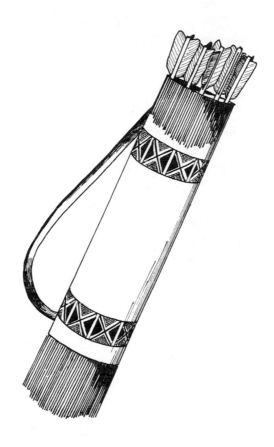

Quiver

An Indian quiver is not difficult and makes a good evening project. As with other crafts in this book, you will probably find that the decorating will take more time than the project.

The actual size of your quiver will depend on the length of the arrows you intend to carry in it. The quiver should be deep enough so that the arrows reach the bottom just before the fletching of the arrows touches the top of the quiver—about 24" is usually a good depth.

The type of leather you use is, of course, up to you. Brain-tanned buckskin is considered the best by many, though others prefer a somewhat stiffer leather. Still others use hide

with the hair still in place. Whatever type you use, you will need a piece about 10" across the top, 8" along the bottom, and 24" along the sides. You will also need two other pieces of leather—a small circle about 3" in diameter and a strip 1" wide and 3 feet long (Figure 127).

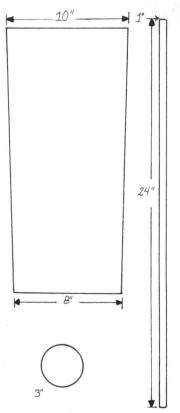

Figure 127.

Begin with the largest piece of leather and sew the two longest sides together, forming a cylinder larger at the top than the bottom. Now the leather disk must be sewn in place. This is done by pressing down a ¼" lip around the edge, forming an inverted cup. Place it in the bottom of the quiver and sew the two lips together. Once this is in place, the leather strip must be sewn on at the top and bottom (Figure 128). This shoulder strap should be set so that it overlaps the seam of the quiver and its length must be adjusted so that it fits the wearer. Too long, and it will flop around—too tight, and you won't be able to get it on.

This will give you a working quiver; however, there is no need to stop at this point. Many tribes used a hard leather cup which attached to a stick and fitted down inside the quiver. This was especially helpful with extra-long quivers or those made of very soft leather. Decoration is, of course, a matter of taste. A row of fringe near the top and another at the bottom looks very good, as does a band of bead or quillwork or a strip of fur.

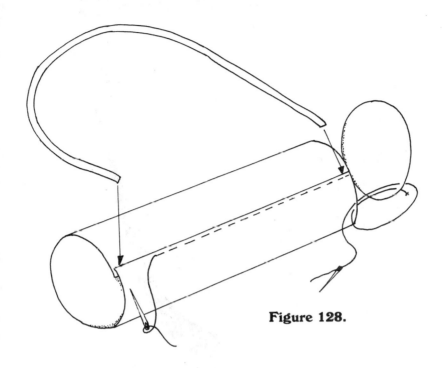

Figure 128.

Figure 129.

Knife Sheath

A knife sheath is one of the easiest items you can make. Take your knife, lay it on the leather, and outline the knife from the point to about halfway up the handle. Then flip the knife over and duplicate the knife again so that the two outlines are about 1/8" apart. Be sure to leave a border of about 3" or more around the outer edges of one outline for fringe (Figure 129). Now cut out the outline, fold along the seam, and sew the edge. (If you can't sew it, punch holes and lace it with leather thongs.) Cut two parallel slits in the back to slip your belt through and cut your fringe about 1/8" wide. If you really want to get fancy, you can decorate the sheath with bead or quillwork.

Figure 130.

Hopi Rabbit Stick

Before the coming of the white man, the Hopi and other Southwestern tribes hunted rabbits and other small game with throwing sticks, much as the Egyptians hunted birds thousands of years ago. The stick used varies widely in shape and length, but basically resembles the nonreturning Australian boomerang. The availability of firearms relegated the throwing stick to the museum display case.

Making a throwing stick is slow and somewhat tedious, though not difficult. First, find yourself a section of tree limb curved somewhat like the Australian boomerang. It should be about two feet long and no more than two inches thick. Cut the

center section about 1/2" thick, the entire length of the wood. Round off the edges until you have a basic airfoil cross-section; then make a handle on the end (Figure 130).

Basically, this is all that need be done, though many models have a slight downward curve on the extreme end. Others, however, have a slight rise. Without doubt, some of these sticks must have had boomerang properties if thrown correctly. The Hopi apparently never figured out the secret of duplicating the throwing sticks that did return.

Much practice is required for proper use. This practice, however, will pay off in accuracy. The stick should be thrown with a sidearm motion, low and parallel to the ground. Using one of these throwing sticks, a good thrower could strike a running rabbit at distances up to 100 feet.

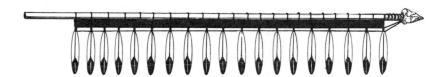

Ceremonial Lance

Whether it is used for dancing or to decorate a wall, the ceremonial lance is truly a beautiful item which you will be proud to own and to show. Originally made by the Plains Indians for ceremonies and for dances, an authentic ceremonial lance is, today, an extremely scarce item. However, with a little patience and work, you can have a lance almost as good as an original.

To make the lance, you will first need the lance head and shaft. To find the head may be the hardest part. Authentic lance heads are rare and quite expensive; however, fakes are rather common and do not cost much unless they are being passed off as authentic. If you are unable to obtain a stone lance head, you can carve one from a 1/2"x 2"x 6" piece of basswood which can be purchased from your local hobby shop (Figure 131). Leave the surface of the head rough so that it resembles stone—then paint it to further the resemblance.

Figure 132.

Figure 131.

The shaft of the lance is the next step. If you can get a young, straight sapling with no branches for 5 or 6 feet, use it—though you will have to trim it down to an even thickness of 3/4" or 1". If you don't have a tree handy, a good lance shaft can be made from a commercial broom handle such as those found in hardware stores. Cut off the threaded end of the handle, then make a lateral cut into the handle about 3" deep. The cut should be at least 1/8" wide. Next, immerse the cut end of the shaft into boiling water for 20 to 30 minutes. This should enable you to wedge the jaws of the slot open and insert the lance head. If you wish, you may now clamp the jaws shut with a vice or C-clamp to give a better fit. Once the wood has dried and taken its permanent shape, the lance head may be removed and glue inserted in the slot before replacing the head. After the glue has set, wrap wet rawhide tightly around

the joint of the spear and shaft (Figure 132). If you cannot get rawhide, use leather strips, as the lance is not intended for use and strength is not essential.

Once the main part of the lance is made, you are ready to begin decorating it. You will need about 20 feathers. Prepare the quills of the feathers in the same manner as you would when making a headdress. Do not, however, put fluffs or horsehair tassels on these feathers. Next, attach a strip of red felt two inches wide and long enough to reach from the head of the lance to within a foot of the end of the shaft. Using leather thongs, tie the felt to the shaft, starting at the head and making a tie about every eight inches. Once the strip is in place along the shaft, attach the feathers about every three inches along the felt. The last step is to run a heavy waxed thread from the lance head along the feathers to make them stand out uniformly.

Throwing Arrows

Though these are actually more similar to javelins or darts than arrows, the term "throwing arrows" has been used for so long that the description has stuck. Originally, the arrows had flint tips but, with the coming of the white man, flint was quickly replaced with iron tips.

To make a throwing arrow requires only a few hours of work and a minimum of materials. First of all, you will need an arrow shaft. This should be about 1" thick by 4 feet long. The handle of a broom works quite well, and hardwood handles such as that used in industrial brooms are best. Next, get a piece of iron or steel rod, 1/4" to 3/8" thick and 8" to 10" long. Lastly, you need several feathers, some strong cord, and glue.

Begin by drilling a hole in one end of the shaft. This hole should be as parallel with the shaft as possible. Next, glue the rod into the hole and let it dry. If you wish to make the joint

Figure 133.

stronger, drill several 1/8" holes through both the shaft and rod and insert 1/8" wire or brass rod through both pieces (Figure 133). The next step is to bind the joint tightly with cord or, if you prefer, wire (Figure 134). The same binding method can be used to make a handle.

A wrapped handle will improve the appearance of your throwing arrow. This simple wrap takes only minutes, yet gives an attractive wrap that holds securely. First, mark the balance point of your arrow—then begin the wrap so that the center of the wrap will cover the balance mark (1). Wrap the cord tightly, making sure that the piece of cord forming the eye is not twisted (2). When the handle is long enough, pass the free end of the cord through the eye (3). Then pull the other end of the cord until the eye disappears under the wrap, and the eye is in the middle of the wrap. To finish, cut off both free ends of the cord (4).

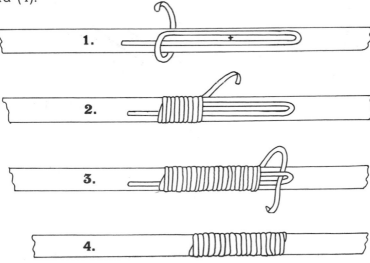

Figure 134.

Now grind the tip of the arrow to a point and, if you wish, shave the back half of the shaft until it tapers to about 3/8" at the rear. Lastly, split your feathers down the middle and tie them to the back of the shaft as you would with an ordinary arrow, and you are ready to use it (Figure 135).

The throwing arrow may be used several ways. First, of course, is target practice. Next, it can be used for hunting small game such as rabbits. A third use is in games. Try to spear a rolling hoop (10" diameter) with it, or you can make another throwing arrow and, with a friend, try another game. The first player throws his arrow as far as possible, then the second player must see how close he can get to it.

A word of warning. Never throw the arrow at hard targets such as wood or stone, and never throw one at or near another person.

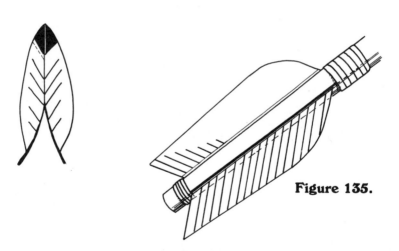

Figure 135.

Materials

One of the most difficult problems in doing Indiancraft is where to find materials. This problem is common to all who do craftwork, whether they live in a city, small town, or the country.

The following may be of some help in locating what you might need. This is by no means a complete listing, nor will each source suit everyone. Someone in the city, for instance, has far more access to stores than the person in the country; whereas, the person in the country will often have a better chance of obtaining animal hides and have the room necessary to tan them, which you cannot do in an apartment.

Wood

Lumber yards are, of course, your first choice if you have the money. You can check with your city maintenance department, as quite frequently they have to trim or cut down trees. If you can catch them cutting one, they usually do not mind you taking some of the wood.

Good bow wood is extremely hard to find. You might check the hardware stores. They often carry wheelbarrow handles of oak or hickory. Usually, any wood that makes a good fence post will make a good bow if you can find one with straight grain.

Rawhide

You can sometimes find this item at your local leather store. Another source of rawhide can be found in your local department or grocery store. The rawhide bones in the pet department can be soaked in water for an hour or so and untied. Then spread out the piece and cut into strips of whatever you need.

Leather & Fur

Start looking for these around your house—old coats and

dresses will often provide leather or fur collars. Old suitcases and brief cases can furnish leather and the tops of worn-out boots can be cut off. Such a piece will provide a long length of lacing, when stripped.

Porcupine Quills

You're really up a tree here unless you know someone who lives in an area where porcupines are common. You will probably have to order them. However, there are substitutes. The quills of small feathers, stripped of their webbing, can be used. If you can locate some maidenhair fern, the stems are almost undetectable from the real thing.

As you can see, a little thinking and searching can save you some money. The main thing to remember is to use your imagination and don't be afraid to try a substitute. You may also want to talk to the Boy Scouts. They usually have access to supplies and knowledge on working with them. A copy of the Boy Scout magazine, *Boy's Life,* will normally have several ads from Indian craft supply houses.

Feather Terminology

Feathers come in many sizes and shapes and the instructions for using them may not always be clear. This section will help when you do not fully understand instructions.

Feather, in this book, generally refers to imitation eagle feathers, made usually from white turkey feathers.

Plumes, sometimes called fluffies, are short, fluffy feathers. They are very soft, wispy, and can be found in different colors.

Hackles are short feathers, usually 6 to 8 inches long, which resemble plumes at their base and more like regular feathers above that. They are very thin and are often used on the tips of larger feathers to give them more color and movement.

Tip is the topmost part of the feather.

Topside, is the side of the feather which is uppermost when the bird is in flight. From the edge view, the webbing comes out from the quill and angles downward.

Underside is, of course, the bottom side of the feather.

Quill is the large round part of the feather which runs the entire length of the feather.

Webbing are the lateral lines running out from both sides of the quill. It is these which make up the feather.

Leading Edge. When a bird is in flight, the edge of the webbing which comes first is called the leading edge. It is usually smaller than the other webbing.

Trailing Edge is the other side of the webbing. This term and the one above usually refer only to wing feathers. Tail feathers usually have very little leading or trailing edge.

Right or Left Feather. This refers to whether the feather was originally on the right or left wing of the bird. This can be easily determined by holding the feather in front of you and looking at the topside. The feather will incline either to the right or left. Whichever way it points is the side the feather was originally on.

Plume.

Hackle.

Feathers.

Leather Strippers

When doing Indian crafts, one of the most frequently needed items is one or more lengths of leather or rawhide stripping. If bought at a store, this can be very expensive. The alternative to buying, then, is to make your own stripping. This is not difficult to do and will enable you to convert small scraps of leather into long strips which you will find extremely useful. There are two kinds of strippers:

Circular Stripper

This is quite simple and requires only a piece of hardwood 1/2"x 1/2"x 4," a 1/8" to 1/4" dowel one inch long, a screw, washer, and an X-Acto blade.

Drill a small starter hole in the end of the wood and insert the washer and screw into the hole. Place the blade flat in between the end of the wood and the washer, with the blade parallel to the side of the wood. Tighten the screw down until the blade is held quite firm (Figure 136). Drill another hole the same size as your dowel on the top of the wood. How far back from the blade you drill this hole will determine how wide the lacing will be. If you want your lacing to be 1/8" wide, measure so that the edge of the hole will be 1/8" from the blade. Once you have drilled the hole, insert your dowel. If the dowel is loose, you may need to glue it. Now you are ready to start stripping.

Figure 136.

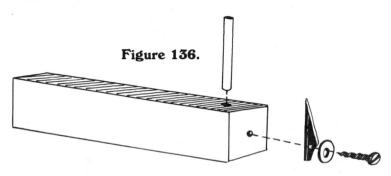

The stripping itself is done by first cutting your scrap leather into a roughly circular shape, then cutting a round hole in the center of it. This hole need not be over one inch in diameter. Now cut a parallel slit in the hole about 3/4" long, and, at its widest, it should be the same width as the lacing you wish to cut.

You may clamp the stripper down or hold it in your hand. Now place the leather on the stripper in the slit you cut. The inside edge of the hole in your leather must rest against the dowel. Grasp the leather tab and pull firmly and smoothly along the line of the knife blade. Guided by the dowel, the blade will cut a spiral strip of leather out of the scrap (Figure 137). It takes a little practice to work the stripper properly and you will have some false starts. Do not get discouraged. Soon, you will find that you can easily make a continuous strip, 20 or more feet long. In fact, the only limit to the length of a strip is the size of your leatherpiece and the width of the strip you are cutting.

're 137

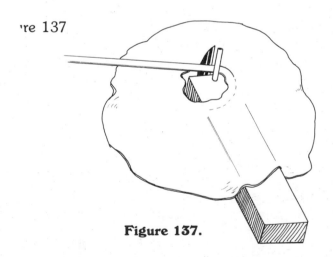

Figure 137.

Straight Stripper

This type of stripper has several advantages over the circular type. To make this, you will need two pieces of hardwood—one piece 1"x 3/4"x 5" and another piece 1 3/4"x 1 3/4"x 1". You will also need a screw, washer, X-Acto blade, and a thumbscrew.

To make the stripper, assemble the larger piece of wood exactly as you did the previous circular stripper, only without the dowel rod or dowel holder. Now, in the smaller piece of wood, cut a square hole, just large enough for the larger piece of wood to slip through endways. The easiest way to cut this hole is to measure and mark the size hole you will need, then drill four holes, one in each corner of your mark. Using a small-bladed saw, such as a coping saw, you can now cut out the center and sand or file it fairly smooth. Next, you must drill a small hole through the wood and insert the thumbscrew (Figure 138). Be careful that the hole drilled is smaller than the screw; otherwise, the screw threads will not be able to grip the wood and it will slip.

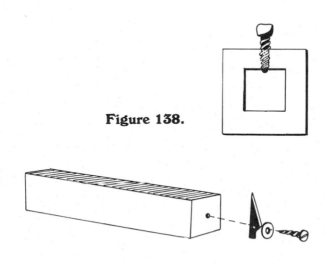

Figure 138.

Figure 139.

To use the stripper, insert the larger piece of wood (the body) into the hole in the smaller piece (the ring). Slide it down until the blade is the desired distance from the ring—1/4," 1/2," 3/4," 1," etc.—then tighten the thumbscrew. Warning: Do not overtighten the thumbscrew as this could result in the ring breaking.

One edge of the leather to be stripped must be straight. If it is not, you must cut it so that it is. This is best done with a straight edge, such as a yardstick and razor or very sharp knife. Place the leather on the stripper with the straight edge against the ring and the front of the leather against the blade. Now pull gently, but firmly. There will be some resistance at first but, as the blade begins cutting better, it will smooth out. Be sure to keep the flat side of the leather against the ring or your cut will be crooked.

With both types of cutters, the blade may tend to slip backwards as the leather resists cutting. Should this happen, it can easily be stopped by driving a small nail or tack into the wood just behind the blade.

Indian Designs

This rather broad field can be divided into two major types of designs—that of the Woodland Indians and the Plains tribes, with the California and the Alaska Indians forming separate, smaller groups with their own designs. Because of their popularity, we shall concentrate on the Woodland and Plains designs and leave the other types of designs to persons who wish to delve more deeply into the subject. On both types of designs, the most popular colors used were usually red, blue, yellow, white, and brown, though other colors were used when available.

Please bear in mind that these designs are not absolute—they are to serve only as models and can and should be changed to suit the taste of the craftsperson.

Plains Designs

Of the two types of designs, the best known are those made by the Plains Indians. These designs are easily recognized by the geometric shapes and the brilliant colors used in them.

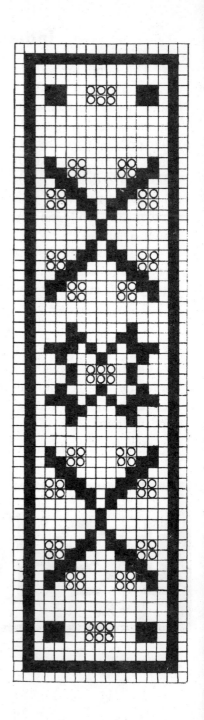

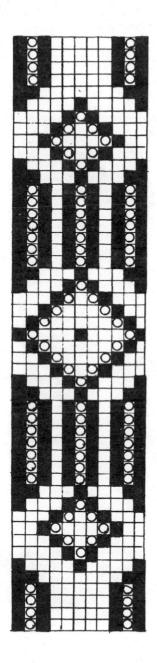
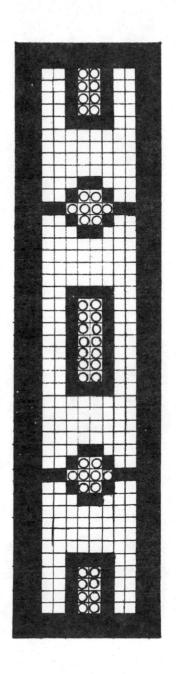

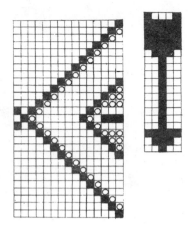

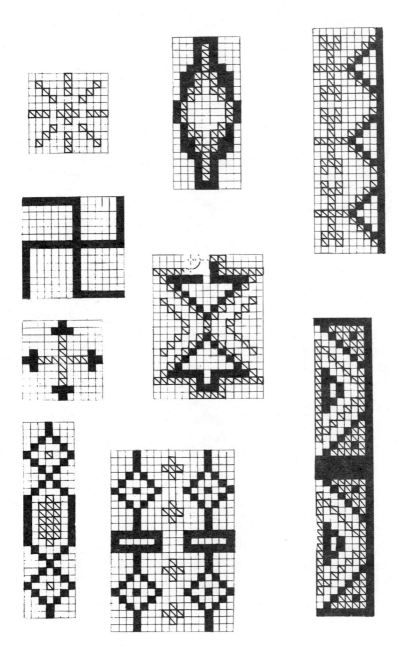

Woodland Designs

The Woodland designs are those used by the Indians who lived in the Eastern forests and along the Atlantic Ocean. Most of these designs are characterized by various types of flower designs worked into the material. The following patterns are perhaps most typical of Woodland designs.

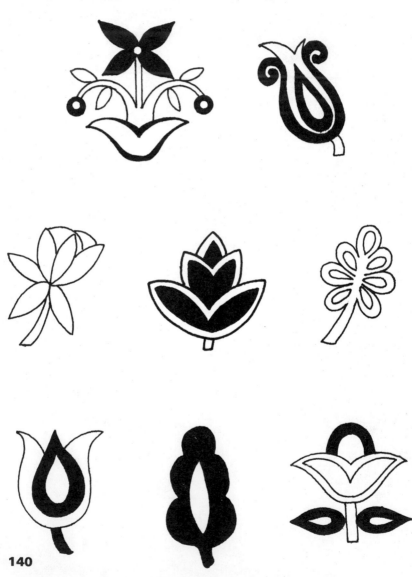

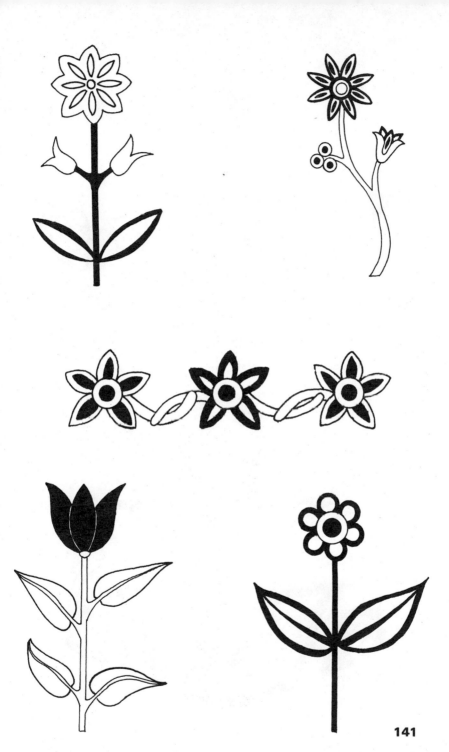

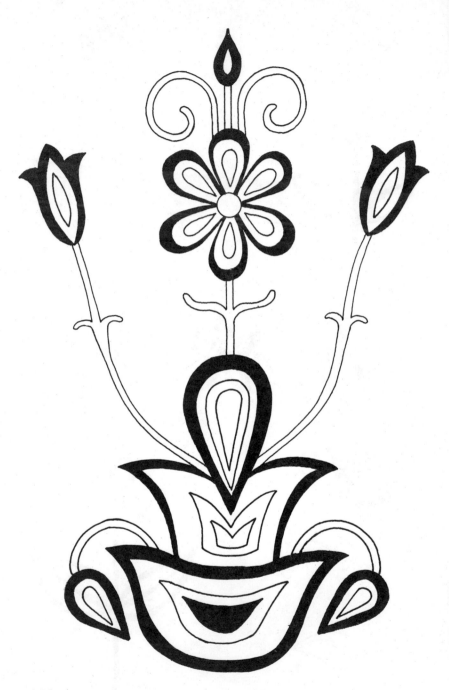